POSTCARD HISTORY SERIES

Erie Canal

On the front over: This image of the Erie Canal paralleling the Mohawk River was a common scene during the life of the canal. What makes it interesting is that the boats are for cargo, and there is the rail line that sandwiches the canal against the river. The people who created, published, purchased, sent, and received these postcards were not riding boats on the canal but were most likely on the railroad. (Erie Canal Museum.)

On the back cover: Please see page 48. (Erie Canal Museum.)

POSTCARD HISTORY SERIES

Erie Canal

Andrew P. Kitzmann and the Erie Canal Museum

ARCADIA
PUBLISHING

Published by Arcadia Publishing
Charleston, South Carolina

Printed in the United States of America

Library of Congress Catalog Card Number: 2008934422

For all general information contact Arcadia Publishing at:
Telephone 843-853-2070
Fax 843-853-0044
E-mail sales@arcadiapublishing.com
For customer service and orders:
Toll-Free 1-888-313-2665

Visit us on the Internet at www.arcadiapublishing.com

Dedicated to my parents, Joyce and Roy Kitzmann.
Your lifelong support of my many eccentricities has defined my enthusiasm
for my choice of both work and play. Thank you.

CONTENTS

ACKNOWLEDGMENTS

The Erie Canal Museum, located in Syracuse, has been collecting, interpreting, and preserving canal history since its inception in 1962. This book would not have been possible without the dedication and years of work by the former curators and especially the current staff, including Rory Bergman, Steve Caraccilo, and Diana Goodsight, who make the Erie Canal a part of their lives. The images in this publication are drawn completely from the museum's collection and represent a fraction of the postcards that have been collected by the museum staff over the years.

The support material that was used to create the text for the images was drawn primarily from the primary source materials and state and county histories found in the museum's collection. Additional information was obtained from the following: the New York State Museum in Albany and the online resources at the University of Virginia and University of Rochester.

Finally, I would like to acknowledge Lindi Paige Kistler, graduate student at Syracuse University, College of Visual and Performing Arts, program in museum studies. Her ability to organize, her editing skills, and her frank advice have been invaluable contributions and have served to make this a better publication than it might have been.

INTRODUCTION

The Erie Canal, which opened across the state in 1825, has always been a source of both fact and legend. The legends were a product of the pride that the residents of the state of New York felt in the waterway. As an internal improvement project, the canal was arguably one of the most complicated and difficult engineering and construction projects undertaken to date by the young nation and certainly by the state of New York.

The towpath canal was closed for good by the state in the spring of 1917, and the barge canal opened the following year. This new canal harnessed the rivers and lakes, and portions of it were man-made. Boat capacity was increased from 260 to 2,000 tons, and the state could boast lock 17E at Little Falls as the highest lift lock in the world at a bit over 40 feet.

Given the success of the Erie Canal, the waterway was a natural subject for postcards. *Erie Canal* details many of the towns, villages, and counties through which the canal passed. The images document the Erie Canal, the lateral canals, and the transition from the historic towpath canal to the modern barge canal.

Erie Canal is organized alphabetically by the name of the canal-side town. The fact that the canal changed in size, shape, location, and purpose over the years creates a great deal of confusion today. *Erie Canal* tries, where possible, to convey both the historic and modern canals.

Because the canal was essentially a cargo-based canal when these postcards were produced, few of the people sending them were actually riding the canal. Instead, they were sending a note with an image that reflected the pride in the accomplishments of the people who built New York's great canal system. This pride continues today as New Yorkers continue to enjoy the Erie Canal.

One

ALBANY THROUGH ELLICOTT CREEK

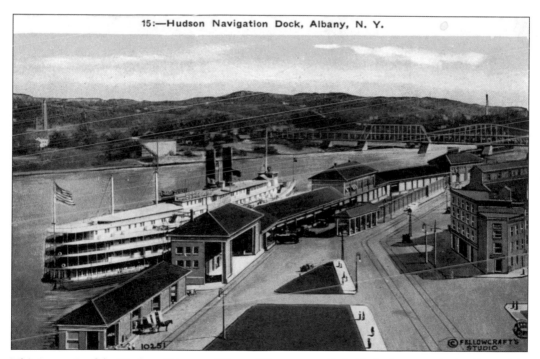

This image is of the Hudson River at Albany. The steamer *Berkshire* is shown at the landing with the Ferry Street Bridge and the town of Rensselaer in the background. The steamers provided the link for the canal between New York City and Albany.

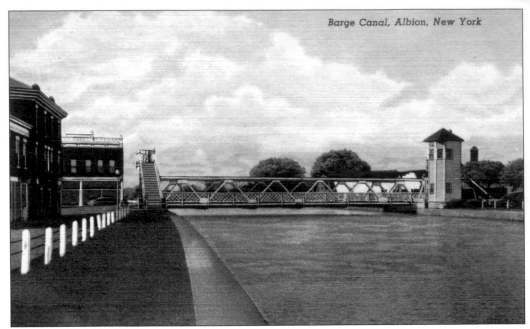

The bridge pictured at Albion on the Erie barge canal is raised when boats travel through the area. The bridge is then lowered to allow road traffic to pass. The Erie Canal was a showcase of bridge design, both movable and fixed. Many of the styles and designs will be found in the following pages.

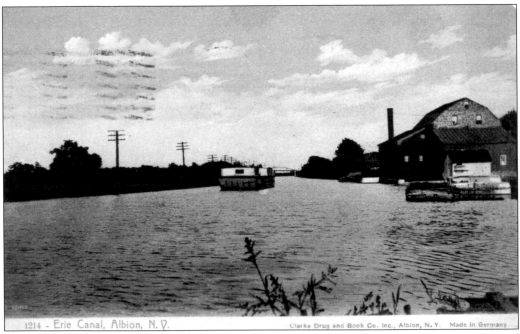

1214 - Erie Canal, Albion, N. Y. Clarke Drug and Book Co. Inc., Albion, N. Y. Made in Germany

Albion is located between Medina and Brockport in the western part of New York. Lake Ontario is a few miles due north. The boat moving along the Erie Canal is riding high in the water and may be heading toward the canal-side barn to take on a cargo.

10

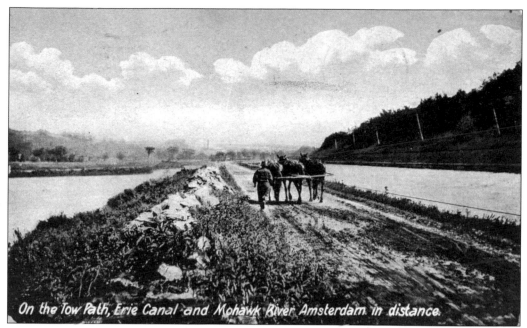

On the Tow Path, Erie Canal and Mohawk River Amsterdam in distance.

This image near the town of Amsterdam demonstrates why the Erie Canal was separate from the Mohawk River. This was done because the animals would not have been able to pull the boats against the current of the river, and the water levels were too unpredictable.

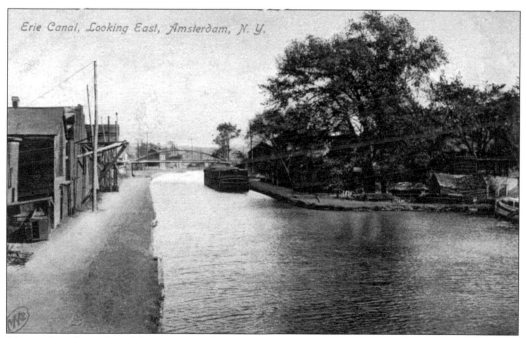

Erie Canal, Looking East, Amsterdam, N. Y.

Pictured to the right of the Erie Canal at Amsterdam is a widewater, where cargo boats docked to unload or halt for the night. To the left are the towpath, warehouses, and block and tackle. The block and tackle were used to load cargo from the warehouse to the boat and back again.

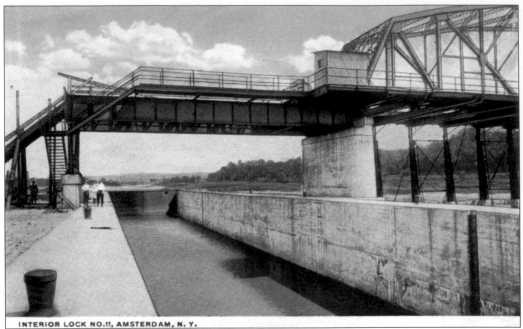

INTERIOR LOCK NO.11, AMSTERDAM, N. Y.

Amsterdam is the site of the integrated system of lock 11 and a movable dam built to control water levels on the Mohawk River. The movable dams allowed the water level to be controlled as the river fluctuated between flood and trickle. The Erie barge canal was built to have an average water depth of 12 feet.

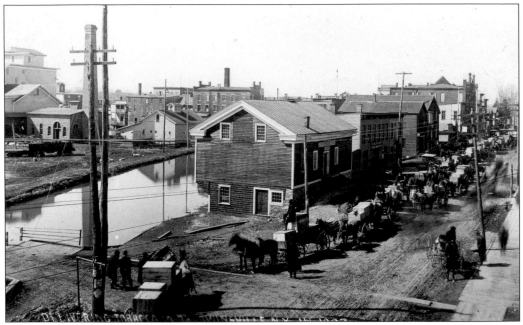

The Baldwin Canal was a short, navigable feeder canal that connected the town of Baldwinsville with the Erie Canal. Note the construction of the building in the foreground. The structure is recessed at the bottom to allow canal boats to dock directly under the building and load or unload cargo. The carts are all full of tobacco.

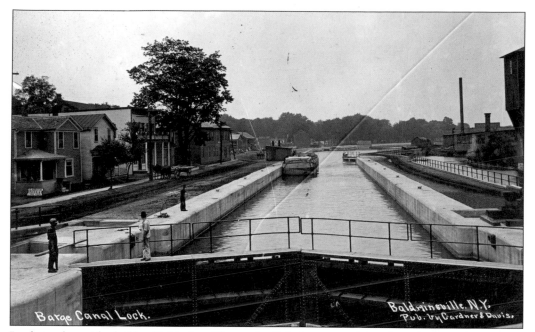

Lock tenders at lock 24 at Baldwinsville on the Erie barge canal watch as the gates behind the boat are closed. The boat is a converted towpath–era boat, indicating the image was taken early in the 20th century.

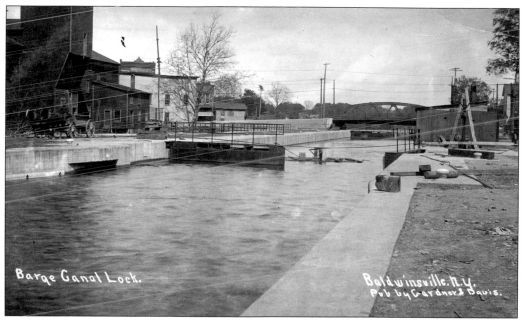

The horse and buggy driving next to the modern Erie barge canal at Baldwinsville speak to the drastic shift in transportation methods. When the barge canal opened in the spring of 1918, it completely replaced the old animal-powered Erie Canal as well as the feeder canals like the Baldwin Canal.

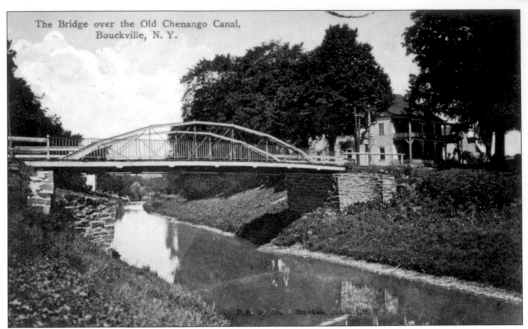

The Chenango Canal joined the Erie Canal near Bouckville. The Chenango terminated in the southern part of the state at Binghamton. The state built many lateral canals like the Chenango along the Erie system. These lateral canals had the effect of giving the Erie Canal access to almost all parts of the state.

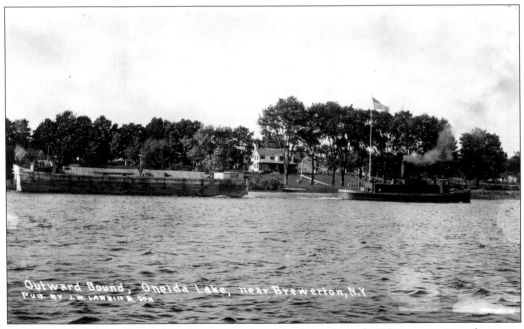

The New York State Barge Canal was completed in the spring of 1918, yet portions that were finished prior to that date were operational. Here in 1915, a tugboat pulls a wooden barge across Oneida Lake near Brewerton. The canal boat is empty and riding high in the water.

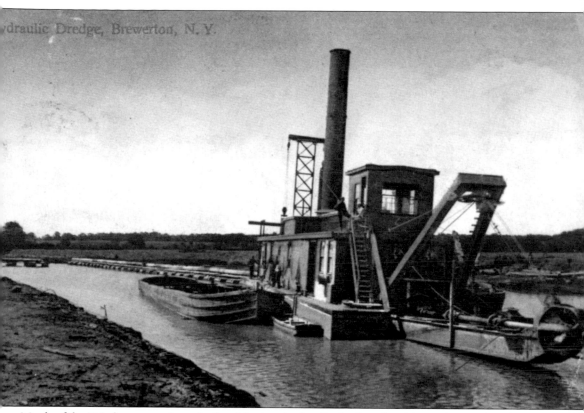

Much of the Erie barge canal was built with giant hydraulic dredges fit with massive 12-foot-high cutting heads. The cutting heads were lowered into the bottom of the canal, and as they were spun, they turned the earth and water to a slurry. The slurry was then sucked through a large tube that was sometimes a mile or more in length and sprayed out onto the surrounding fields to dry. The slurry tube is visible behind the dredge as it extends into the distance supported at the surface of the canal on floating pontoons.

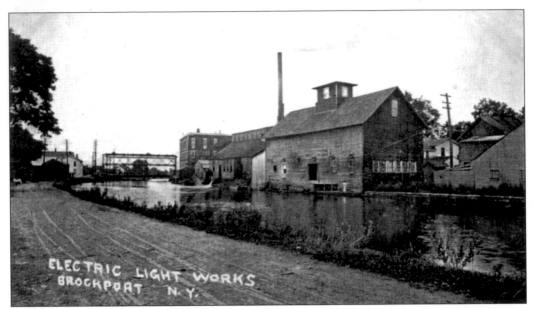

Pictured is the Electric Light Works at Brockport on the Erie Canal. Note the large, square opening in the side of the building. This was used to load and unload cargo directly from the boat into the warehouse.

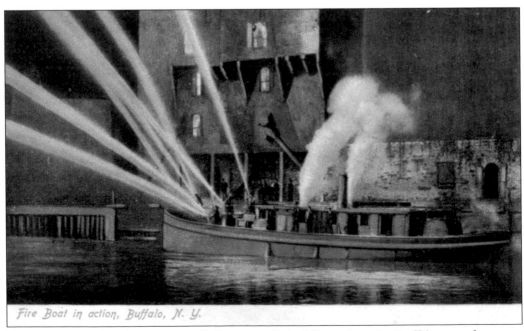

Fire Boat in action, Buffalo, N. Y.

A steam-powered fireboat uses spotlights to search buildings along the Buffalo waterfront.

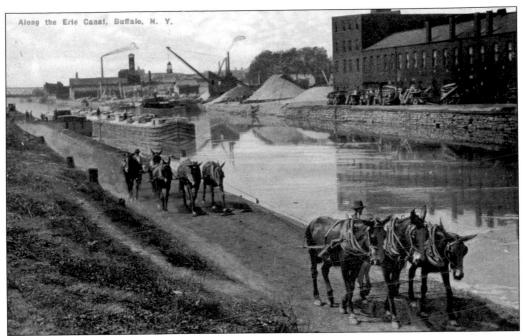

The railroad was the primary transport mode by the end of the 19th century. The Erie Canal was relegated to shipping bulk materials that the railroads did not want to deal with. These included cement, lumber, coal, and other bulky products. At this point, the canal was picking up current from Black Rock Creek, necessitating teams of three or more animals to pull against the current. Typically, two animals were sufficient to pull the boats along the rest of the canal system.

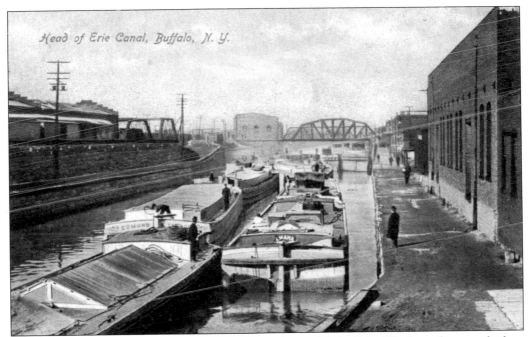

This is the harbor at Buffalo where the Erie Canal joined Lake Erie. The boats have stacked up as they jockey for position in the canal system.

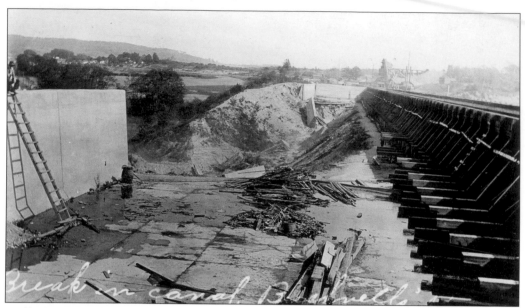

Cofferdams have been installed to allow workmen to repair a break in the Erie barge canal at Bushnell's Basin.

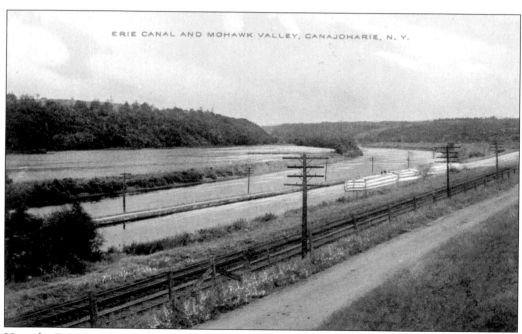

ERIE CANAL AND MOHAWK VALLEY, CANAJOHARIE, N. Y.

Here the Erie Canal is sandwiched in between the railroad, a dirt road, and the Mohawk River. The towpath is located on the berm between the river and canal. Telegraph lines follow both the railroad and canal path.

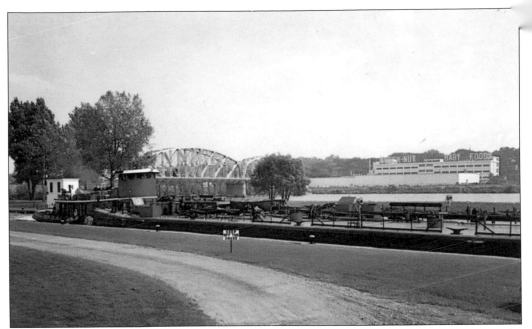

A tugboat pushes an oil barge through the lock at Canajoharie on the Mohawk River. The oil barges accounted for a majority of the commercial traffic on the Erie barge canal. Today the traffic is primarily pleasure boats and the canal is one of New York State's major tourist destinations outside New York City.

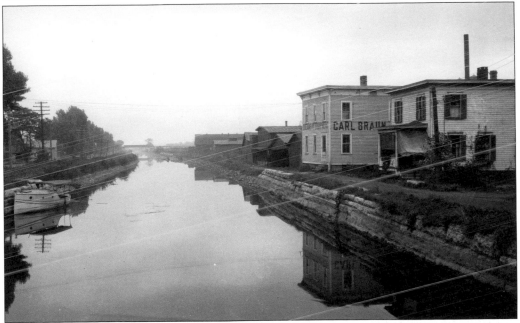

Carl Braun's Creamery Equipment Company was situated directly next to the Erie Canal in Canastota. The creamery must be on the extreme edge of town, because the wall of the canal transitions from stone to earth. Within town, the canal walls were built of stone, creating a 90-degree angle at the bottom to allow boats to dock directly next to buildings. In the country, the canal was built of earth and the walls sloped to the bottom in what is known as a prism.

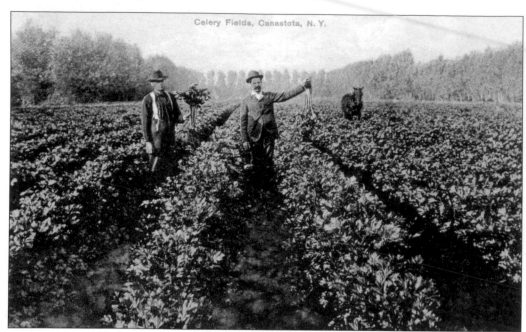

Two men prepare to harvest celery from a field in Canastota. The celery was a commercial product that was shipped to communities across New York State by boats on the Erie Canal.

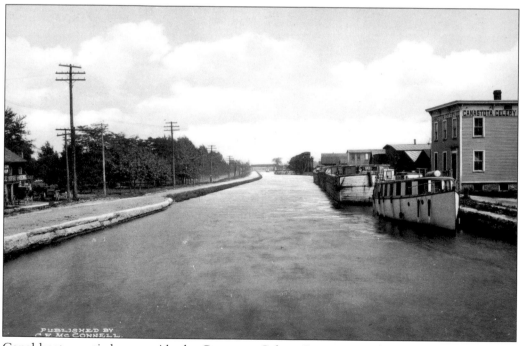

Canal boats are tied up outside the Canastota Celery Company at the Erie Canal. The front boat is for passengers and mail. The square wooden boats in the background are cargo boats that hauled the town's celery crop and other commodities across the state.

The packet boat *Queen City Patchoos* is moored in the widewater that precedes the Canastota hoist bridge at the Erie Canal. The bridge was a complicated piece of equipment. The bridge abutments rise on either side of the canal in a pair of columns reminiscent of Greek Revival architecture. As a boat prepared to move along the canal, the bridge was then hoisted to the top of the columns. After the boat passed, the bridge was brought back to street level. The hoist bridge at Ilion is shown on the cover of this book.

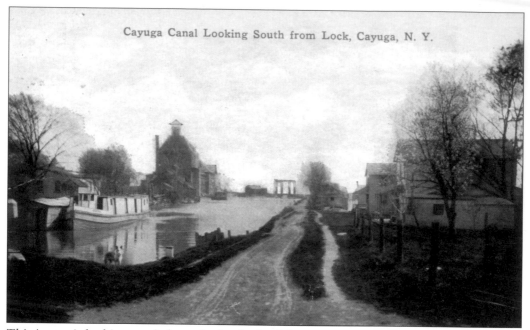

Cayuga Canal Looking South from Lock, Cayuga, N. Y.

This image is looking south from the last lock of the Cayuga Seneca Canal prior to entering Cayuga Lake. In addition to the Erie, New York State boasted a vast network of lateral canals throughout the state.

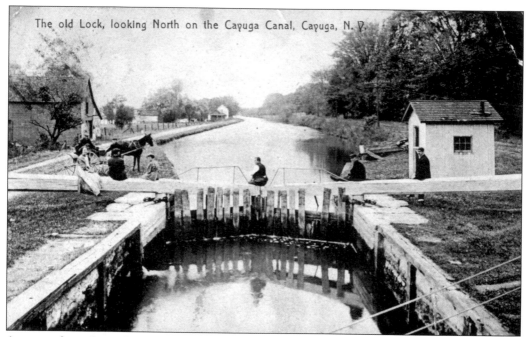

The old Lock, looking North on the Cayuga Canal, Cayuga, N. Y.

A party of travelers relaxes on the lock gate arms and miter point at the Cayuga Seneca Canal. The lock tender's house is on the right. The structure was typical of New York's canals, with dimensions of 8 by 10 feet. The structure was sparse, containing little more than a wood stove, table, and latrine, naturally routed directly into the canal.

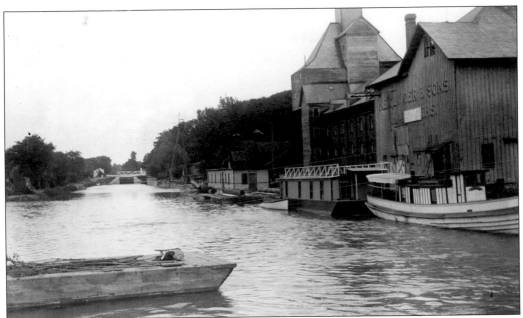

The buildings on the right of the image advertise fruit trees. The boat in the foreground is a scow, designed for repair work on the Cayuga Seneca Canal. The front boat on the right is a mail boat, and the one behind it is a quarter boat. The quarter boat was a floating motel for construction workers on the barge canal. The tubes resting on pontoons in the center of the image are pipes that carry material dredged from the canal bottom to slurry fields.

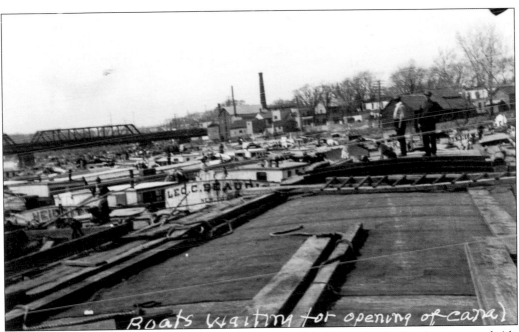

The canal is nearly open for the season. The state is simply waiting for the floodwaters to subside enough to allow safe navigation. In the meantime, the anxious boat captains have begun the process of staggering their boats in readiness for entering the canal system.

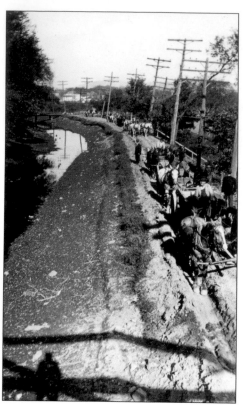

This image of the Champlain Canal illustrates the sheer amount of physical labor required to maintain it. This crew will be put to work clearing out sediment in the canal bed and reshaping the prism, the sloped walls of the canal chamber.

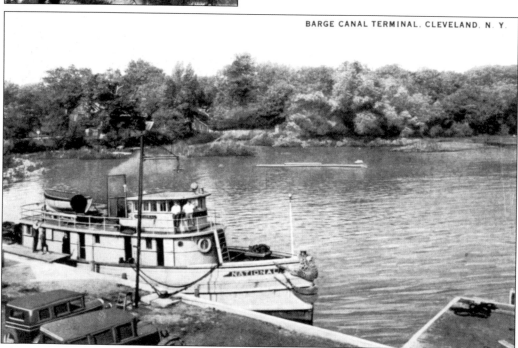

BARGE CANAL TERMINAL, CLEVELAND, N. Y.

The tug *National* is moored at the terminal in Cleveland, New York, on Oneida Lake. The terminals on the barge canal served as links to local cities and as maintenance and administration points on the canal system.

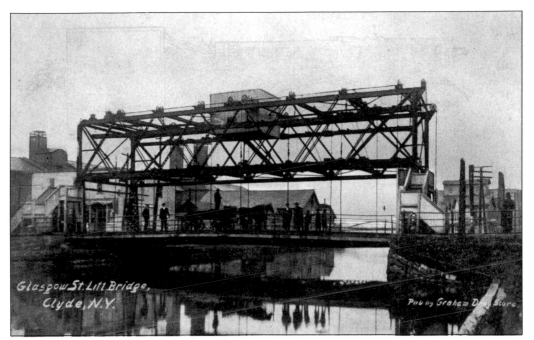

A wagon team crosses the lift bridge of the Erie Canal in Clyde.

Boats of all types were used on the Erie. The Erie Canal's rules were clear for all of them, especially the use of lanterns. Note the lanterns on the roof of the boat. At night, the state required that docked boats and running boats have lamps. There were no other light sources on the old towpath canal, yet because boats were allowed to operate 24 hours a day, moored boats needed to be identified in the pitch black.

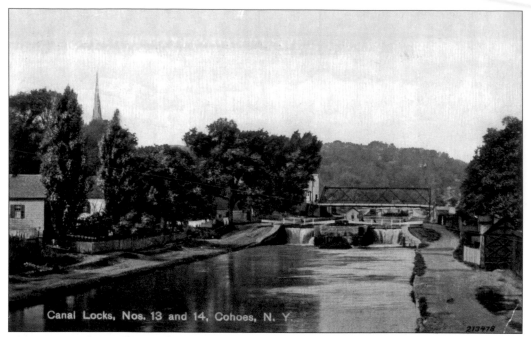

Canal Locks, Nos. 13 and 14, Cohoes, N. Y.

213478

The Erie Canal at Cohoes had a series of locks to negotiate the major rise in elevation. Pictured here are lock 13 and in the distance lock 14 behind the bridge. Later some of the sections of the canal were incorporated into the raceway of the School Street power plant.

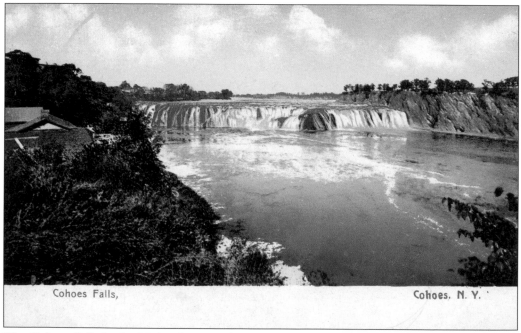

Cohoes Falls, Cohoes, N. Y.

The Cohoes Falls in the Mohawk River demonstrate the drastic rise in elevation here. Today a hydroelectric power plant has harnessed the falls. The Erie barge canal is not part of the river at this point; rather, it skirts the falls and river to the south and reenters the river west of Cohoes.

The Erie Canal crossed the Mohawk River at two points, Crescent and Rexford. The aqueduct at Crescent was known as the Lower Mohawk River Aqueduct. It was built to allow the canal engineers to avoid difficult terrain on the south side of the river.

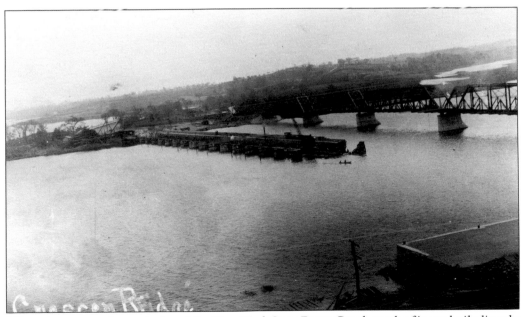

When the state engineers designed the New York State Barge Canal, much of it was built directly into the river. To make way for the canal, the aqueduct at Crescent was removed. The new bridge spanning the river behind the remains of the aqueduct is a railroad bridge.

The owners of the canals and railroads were fierce rivals. New York State owned the Erie Canal, and the state legislature did everything in its power to preclude the railroad from operating. The railroad system became powerful nationally and was able to bring about the state's worst fear: direct competition.

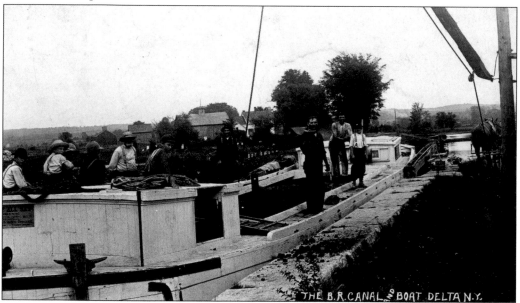

The rope entering the center of the boat's cargo hold at the Black River Canal is controlled by the block and tackle on the right of the image and was used to swing cargo into and out of the hold of the boat. The children on the boat were not enjoying an adventure on the canal. They were there to work, and with no existing child labor laws, they would have worked hard. On the bow of the boat is a sign advertising Crystal Spring water. The side of the sign that is out of the picture indicates beer in addition to the water, which is what the Crystal Spring Brewery in Syracuse was famous for.

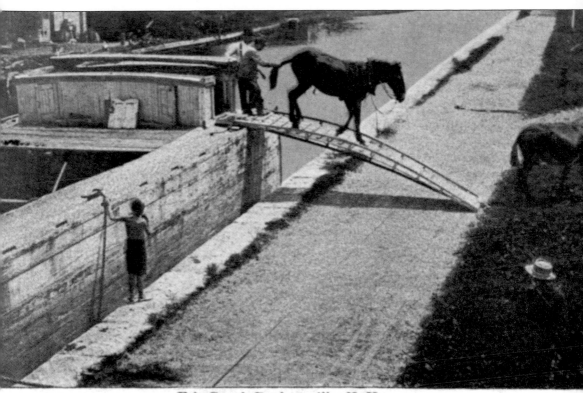

Erie Canal, Durhamville, N. Y.

The mule driver is tailing off the animal. The point is not to physically slow the animal as it walks down the ramp of the Erie Canal; rather, the animal senses the man behind him because of the pressure on the tail and consciously slows itself down. The practice of slowing the animal was critical to efficiently embarking and disembarking the animals because of the narrowness of the plank.

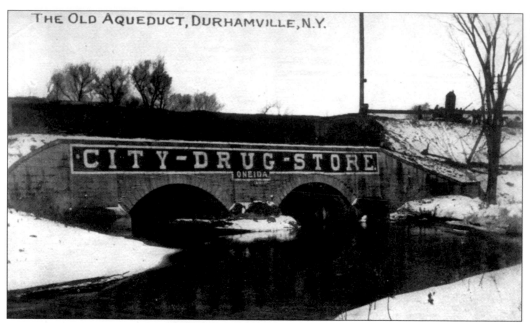

The Erie Canal was closed and abandoned by New York State in the fall of 1917. Many of the structures, including this aqueduct in Durhamville, found new life supporting the state's expanding road system.

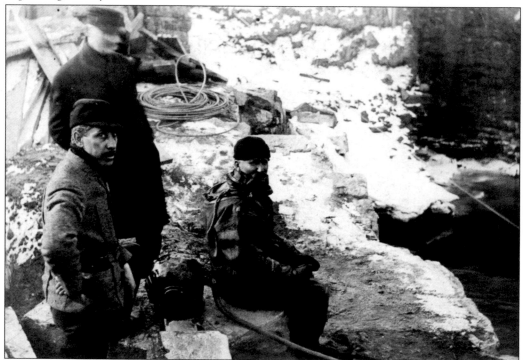

The diver is preparing to conduct repairs on the culvert that allows Oneida Creek to flow under the Erie Canal. Divers conducted repairs to the canal system if the work was not too complicated and also provided appraisals of underwater damage. This work is being done in winter. Often major repairs were scheduled after the canal season closed to avoid shipping delays during the season.

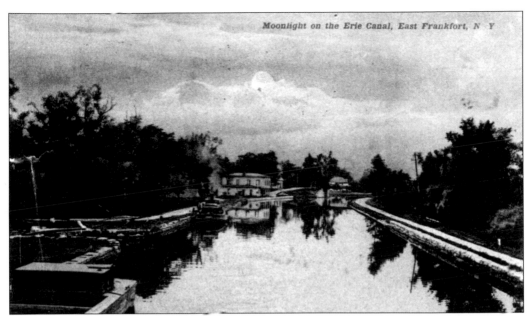

A side cut lock is visible to the left of the image of the Erie Canal. The side cuts had multiple uses, including providing access points for dry docks and ways to get to towns and villages that were not on the direct canal route. This image depicts the canal at night at East Frankfort. While many boats had permits to operate on the canal at night, the boats in this image appear to have moored for the evening.

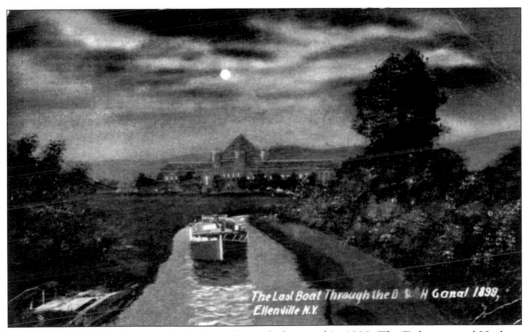

The Last Boat Through the D & H Canal 1899, Ellenville N.Y.

The card states that this was the last boat through the canal in 1899. The Delaware and Hudson Canal was primarily used for shipping Pennsylvania coal. The canal was designed by Benjamin Wright, one of the principal engineers on the Erie Canal, and it connected the Pennsylvania coalfields with the Hudson River.

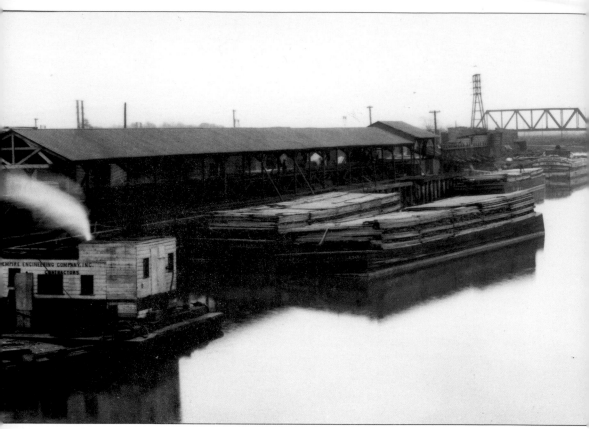

Canal boats have brought lumber to be unloaded at Ellicott Creek near Buffalo and North Tonawanda in 1915. The Empire Engineering Company was one of several contracting companies engaged by the state of New York to build the New York State Barge Canal.

Two

FAIRPORT THROUGH MOHAWK

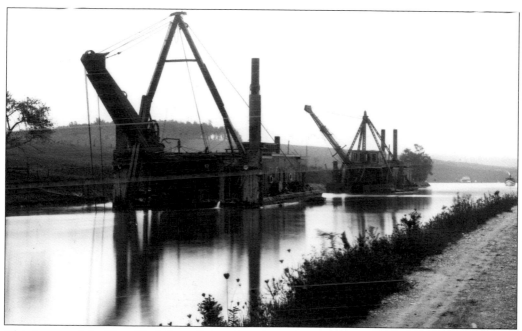

This image of the New York State Barge Canal construction was taken at a widewater west of Fairport in September 1918. The dredges allowed the state engineers to cut the canal through any obstacles encountered. The machines built by the Bucyrus Company in Chicago were coal fired, and the boats were so expensive that they were operated 24 hours a day seven days a week to keep them profitable.

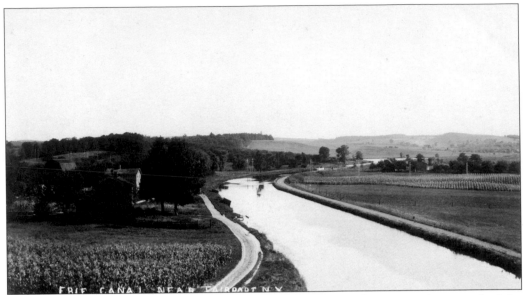

The Erie Canal was certainly not the straight arrow of myth. The state engineers snaked the canal around as many obstacles as they could to avoid creating locks and other structures. Here the canal meanders through the countryside of western New York near Fairport.

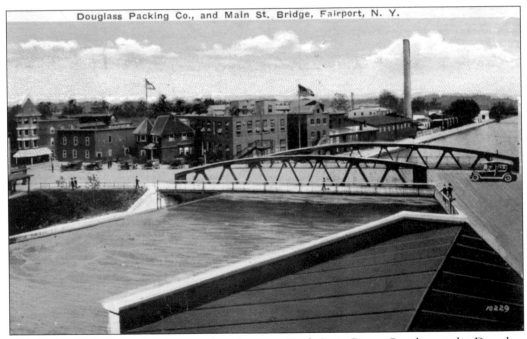

This is the Main Street bridge crossing the New York State Barge Canal near the Douglass Packing Company. The image was taken in the early 1920s.

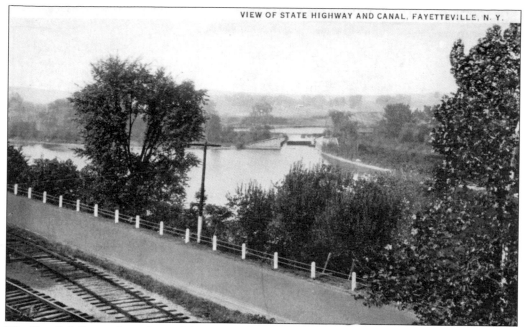

The Burdick Street Aqueduct of the Erie Canal is shown in the upper right of the image. The aqueduct opens up into the Fayetteville widewater. A widewater was created to provide a place for boats to stop and load and unload cargo. The cargo was then transported up the Fayetteville Feeder Canal to the village.

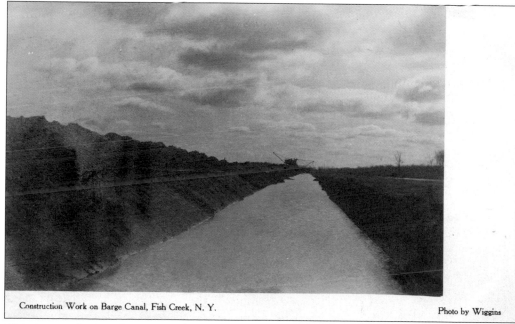

Construction Work on Barge Canal, Fish Creek, N. Y. Photo by Wiggins

This image depicts the tremendous amount of fill removed from the Erie barge canal bed during construction. The waste is piled on the left-hand side of the image. In this instance, a ladder dredge is being used to scoop the material and place it on a conveyor. The conveyor then deposits the fill on the opposite side of the dredge to be cleared at a later time or used for construction of the berm.

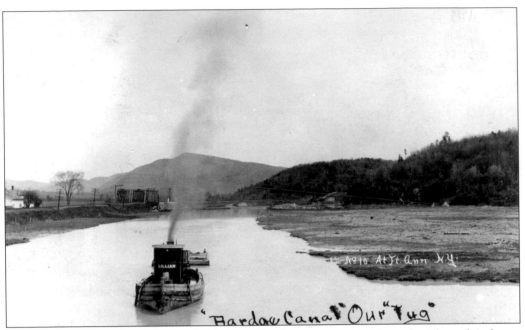

The tug *Lillian* is shown hauling a loaded wooden barge around 1908 on the Champlain barge canal near Fort Ann. The barge canal was not operational statewide until 1918. However, as sections were completed, they were put into operation.

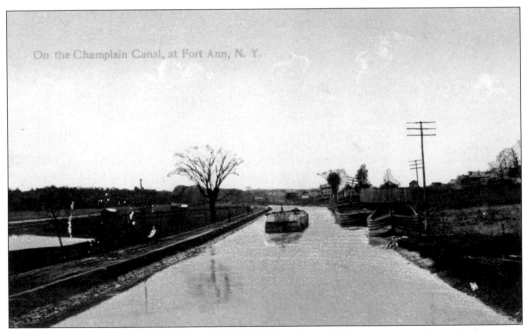

A pastoral scene on the Champlain Canal is depicted here. The boats moored on the berm, or non-towpath, side of the canal may be abandoned. The serviceable life of the wooden canal boats was about 10 years, at the end of which they were often docked and forgotten.

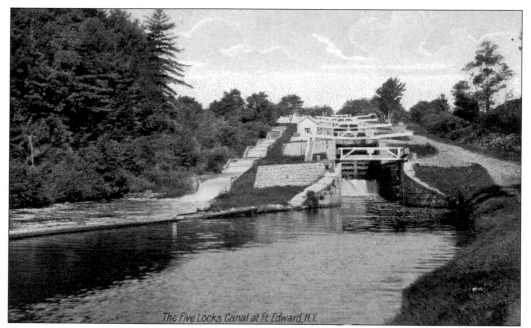

The Five Locks Canal at Ft. Edward, N.Y.

Towpath-era locks in the Glens Falls Feeder of the Champlain Canal had a maximum rise of about 12 feet. To surmount larger obstacles, multiple locks were built, similar to a set of stairs in a house. The stepped waterfall to the left of the locks provides a point of overflow for excess water from the locks.

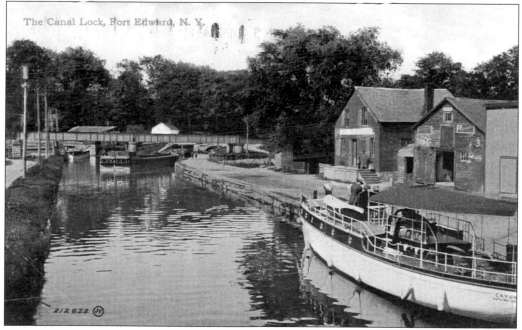

The Canal Lock, Fort Edward, N. Y.

The time required for a boat to go through the multiple locks at Fort Edward allowed passengers the opportunity to disembark and do some shopping. Both general stores and taverns were common at all canal locks throughout the system. This photograph was taken in the Glens Falls Feeder at the Champlain Canal.

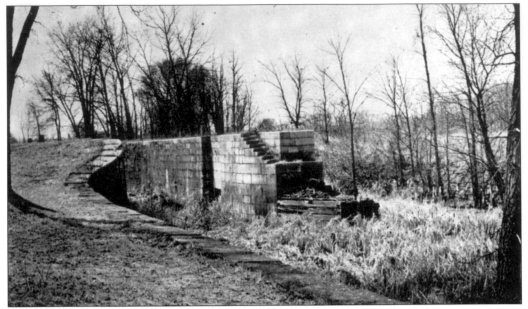

The stonework of the locks at Fort Hunter still stands more than 125 years later. The site is a tribute to the master stone craftsmen of the 1820s. Stonemasons were skilled laborers; however, convict labor was also used in stonework on the canal system. The practice was obviously unpopular with the paid laborers who were constantly competing for work, and riots over the practice happened occasionally.

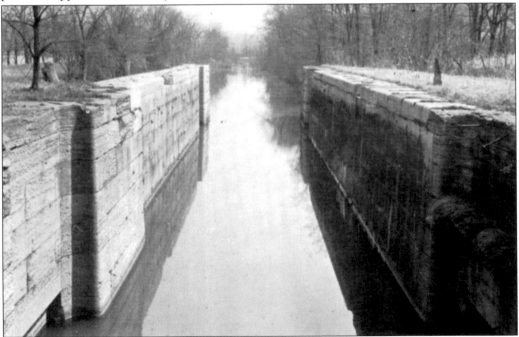

The remains of lock 28 on Yankee Hill near Fort Hunter are depicted. The lock was built as part of the Erie Canal enlargement, a project that took place between 1836 and 1862 and enlarged the canal from a depth of 4 feet and a width of 40 feet to a depth of 7 feet and a width of 70 feet. The Yankee Hill lock was rebuilt in 1841.

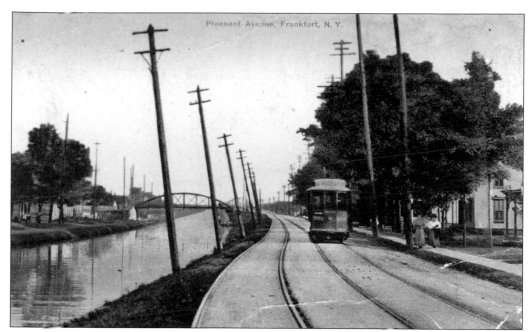

Here is a wonderful illustration of Pleasant Avenue in Frankfort and the impact of the Erie Canal on the local villages and towns. The canal provided the template for expansion of local transportation like the trolleys and a clear line for the telegraph company to run its lines to parallel both sides of the canal.

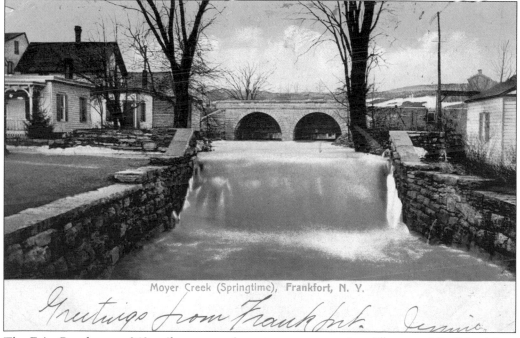

Moyer Creek (Springtime), Frankfort, N. Y.

Greetings from Frankfort. Jennie

The Erie Canal was a 363-mile man-made waterway connecting Albany and Buffalo. Many obstacles were encountered as the canal snaked its way across the state. The double-arched aqueduct at Moyer Creek near Frankfort in the Mohawk Valley is an example of the way larger creeks and rivers were crossed. A simple culvert would have sufficed for a smaller creek.

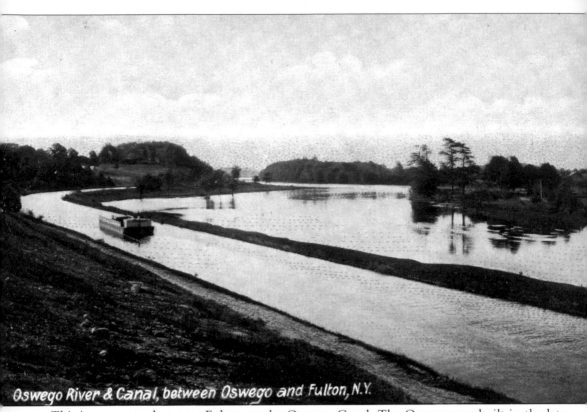

Oswego River & Canal, between Oswego and Fulton, N.Y.

This image was taken near Fulton on the Oswego Canal. The Oswego was built in the late 1820s immediately after the Erie Canal was completed. By then, it was clear to the American government that relations with the British government in Canada had improved. The original plans for the route of the Erie Canal, developed at the conclusion of the War of 1812, completely circumvented Lake Ontario so as not to provide an opportunity for the British to influence the American financial markets via the new canal.

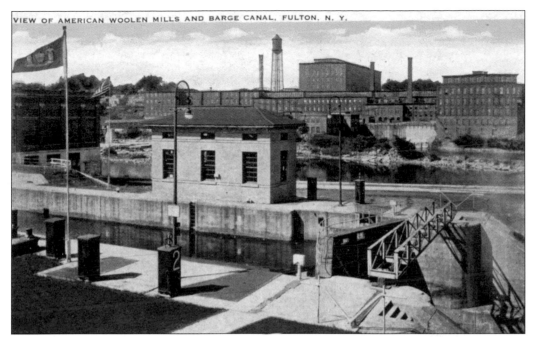

The American Woolen Mills on the west bank of the river was known for production of Civil War uniforms. These uniforms were then shipped down the Oswego Canal, across the state on the Erie Canal, and joined the flow of material heading south into the war theater. The lock is O2 (Oswego 2) and is part of the barge canal system. Visible are the lock chamber, gates, powerhouse, and crossing bridge.

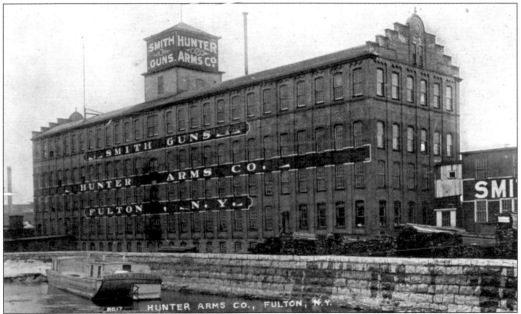

The Hunter Arms Company was owned by L. C. Smith Guns, which later became L. C. Smith Typewriters. Hunter Arms was known for producing excellent break action double-barreled shotguns from the mid-1800s to the very early 1900s. The factory shown in the image was completed in 1889 and was located at the Oswego Canal at Fulton.

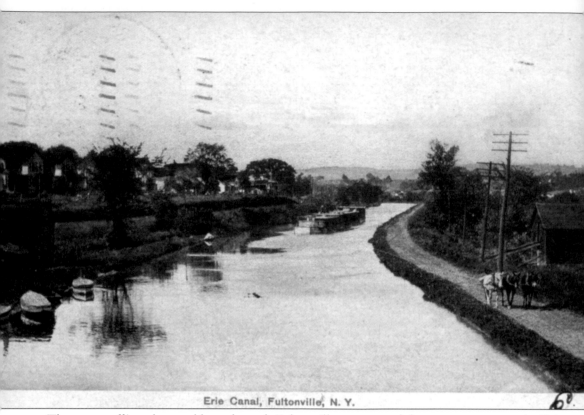

Erie Canal, Fultonville, N. Y.

The team pulling the canal boat through Fultonville represented the power source on the Erie Canal from the point when the first completed section opened in 1819 until the canal closed in 1917. As engines were developed, many attempts to create a prop that did minimal damage to the earthen canal walls were proposed. Most attempts failed, and motors were typically confined by the state to the harbors or areas of the canal such as within cities where the walls were reinforced with stone.

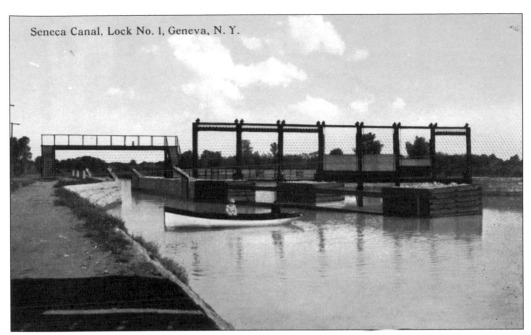

Seneca Canal, Lock No. 1, Geneva, N. Y.

After entering the lake from the canal at lock 1 on the eastern side of Geneva, the boats waited in the harbor for the tugs. The boats were then coupled together and towed south to the Cayuga Seneca Canal.

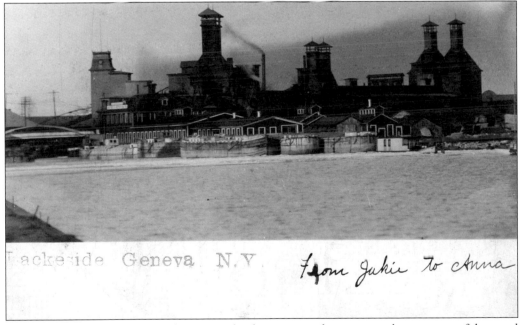

Lackeside Geneva N. Y *From Jukie to Anna*

While the Cayuga Seneca Canal was completely a man-made structure, the successes of the canal system depended upon the ability of boats to transition into natural bodies of water. Here the canal is connecting with Seneca Lake at lock 1. Boats were then pulled down the lake by tugs to Watkins Glen or the Crooked River Canal at Penn Yan.

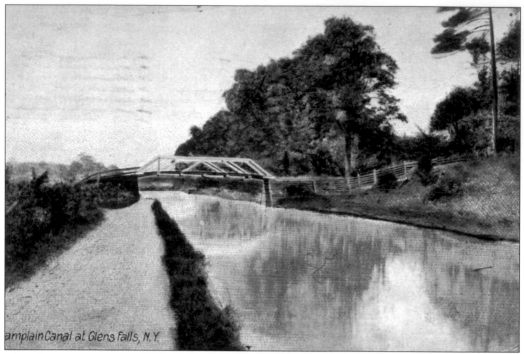

The Glens Falls feeder was completed in 1829 and was later rebuilt to accommodate boat traffic as part of the major canal expansion between 1835 and 1862. The feeder was built to connect the town of Glens Falls with the Champlain Canal near Fort Edwards.

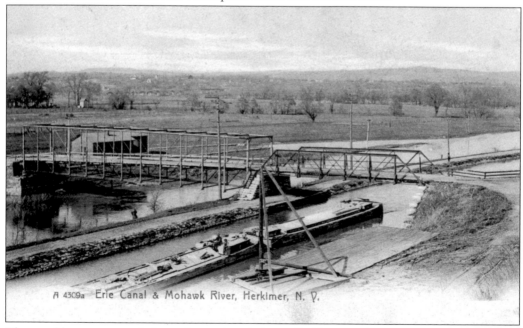

The canal boats are coupled together and are being pulled by a single team. The structure in the lower middle is a derrick for loading cargo onto the boats. The location of the bridges spanning both the Erie Canal and the Mohawk River is a natural loading point for wagons from the surrounding communities.

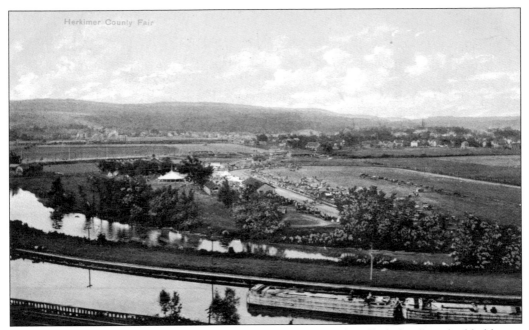

The Herkimer County Fair appears to be in full swing as a "hoodledasher," or doubled boats, pass by on the Erie Canal. The fair is nestled into the natural curve created by the riverbank of the Mohawk.

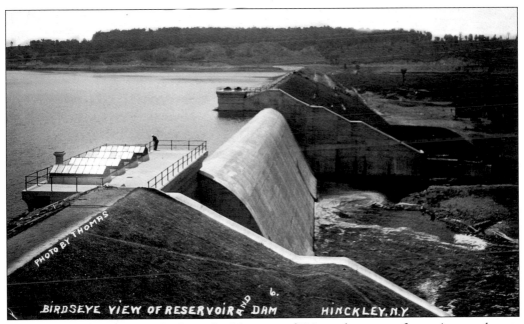

The Hinckley Reservoir was built north of the town of Utica and was one of many impoundments designed to hold water for the barge canal system. Like the old towpath canals that preceded it, the Erie barge canal also relied on gravity to move the water through the locks. The constant flow of water required that the state have a continual and sustainable water supply.

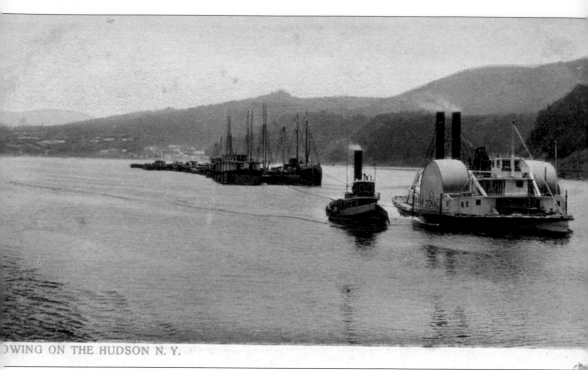

OWING ON THE HUDSON N. Y.

The Hudson River is an often overlooked, yet wholly critical part of the success of the Erie Canal. The ability to tow the canal boats to and from New York City was a major reason why the city exploded into a worldwide commercial port. Without the advantage of a continuous water route from the city to the Great Lakes and the Midwest, New York City would not have become the principal point of entry for the United States, meaning Philadelphia and New Orleans would most likely have assumed that role.

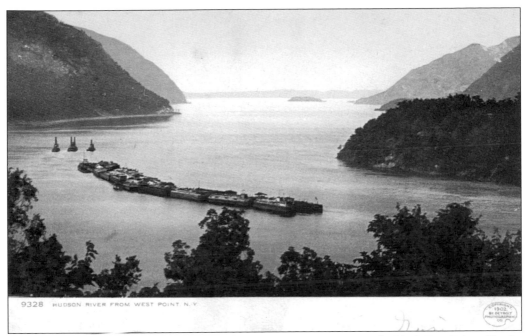

The trip between the canal at Albany and the shipping at New York City's East River Docks was long. In this image, three tugs are used to pull the massive raft of boats.

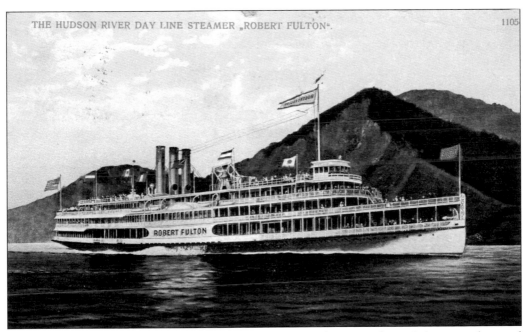

THE HUDSON RIVER DAY LINE STEAMER „ROBERT FULTON". 1105

Steamboats were a common sight on the Hudson River as they moved people between the canal system and New York City. The steamer *Robert Fulton* was named after the man who put the idea of the steamboat into practice. He did not invent the steamboat, as is commonly misconstrued. Fulton's first boat, the *Clermont*, was tested in 1807 and made a 32-hour trip to Albany on the Hudson River.

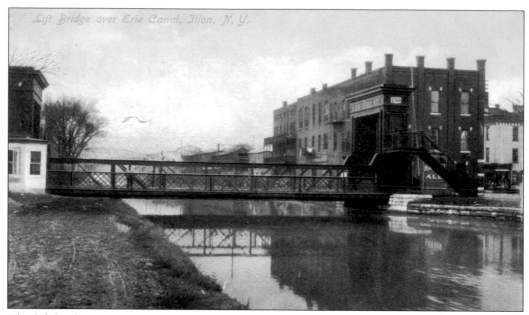

The lift bridge at Ilion on the Erie Canal was designed for the span to rise vertically with the deck remaining parallel to the water below. The advantage of a lift bridge is that fewer counterweights are needed as compared to a bascule bridge (see the Syracuse section, page 102). The disadvantage is that it had a maximum height when raised, so some boats may have been restricted from passing underneath.

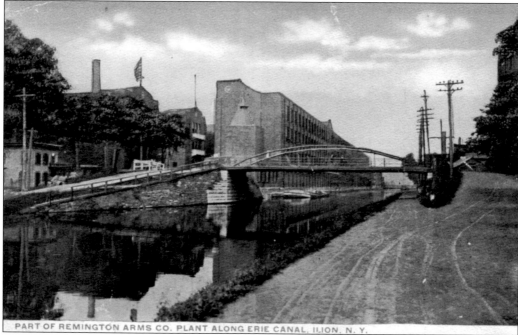

PART OF REMINGTON ARMS CO. PLANT ALONG ERIE CANAL, ILION, N. Y.

The Remington Arms factory is the brick building constructed on the left of the Erie Canal. The factory truly came into its own by providing guns to the federal government during the Civil War. Like other war materials, the weapons were shipped east on the canal to the Hudson River and then to New York City. At that point, they were shipped where needed.

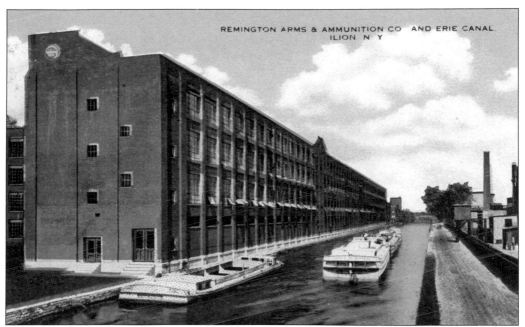

Here a canal boat is docked alongside the Remington Arms factory. The docked boat is very low in the water and is either bringing raw materials to the factory or has just taken on a cargo of finished weapons.

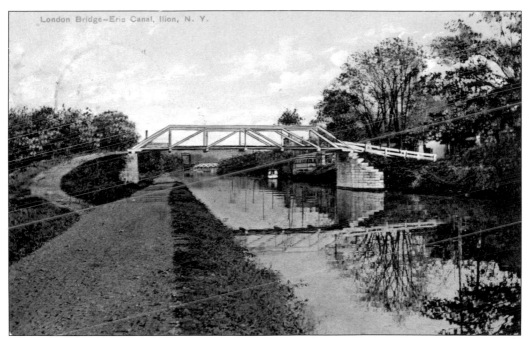

A simple bridge crosses the Erie Canal at Ilion. This is the typical canal scene found throughout the system.

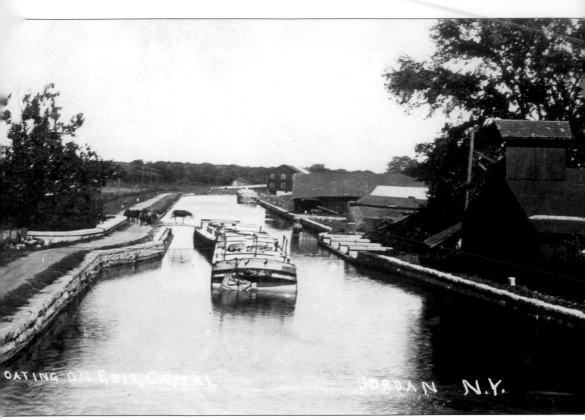

A mule team is being switched near Jordan at the end of the trick, or six-hour shift, of pulling the canal boat. The off team will be loaded into the forward cabin until it is time to switch up the teams again. The structure to the immediate right of the boat on the berm side of the Erie Canal is a waste weir. The waste weir was designed to shunt excess water from the canal into local streams. The odd jutting of the canal bank on the towpath side indicates that a small aqueduct carries the canal over a creek.

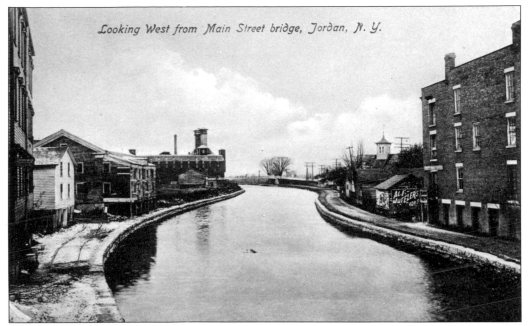

Looking West from Main Street bridge, Jordan, N. Y.

Within the town of Jordan, the canal carved an elegant ribbon of curves. The town had a reputation for the many bars and brothels located around the lock, which was in the center of town. When the state expanded the Erie Canal and the Jordan lock was rebuilt in 1847, it was moved about two miles out of town to solve the problem of boats stopping within the town at the bars and brothels.

The steamer *Chateaugay* moves along the lake on a calm day. Postcards, which traveled very publicly, often contained private notes. In this case, a person named Jean has tried to take advantage of people's curiosity by writing backward. The note says, "You are needed in the Navy!!!!"

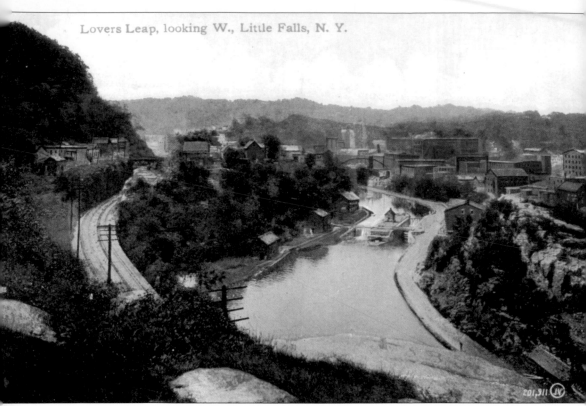

This image is looking west from a promontory of rock at Little Falls known as Lovers Leap. The town of Little Falls preceded the Erie Canal and had one of the first miniature canals in the state. The Little Falls Canal was begun in 1793 and completed in 1795 by the Western Inland Lock Navigation Company. It was then rebuilt in 1802. The canal was constructed so that the bateaux boats could navigate around the falls without portaging.

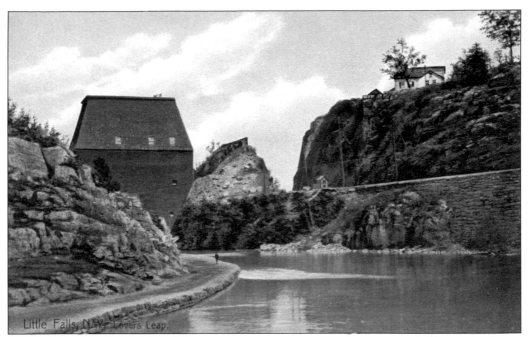

Here is Lovers Leap as seen from the Erie Canal. The large angled building to the left is a warehouse designed to load canal boats by dropping grain or other items into the boat from above.

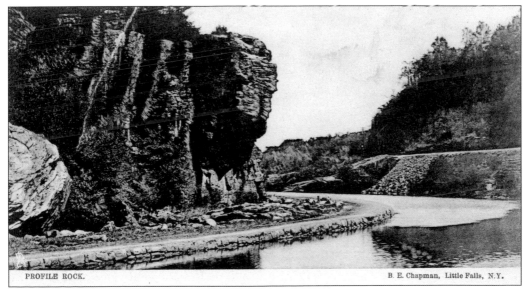

This view of the famous Profile Rock near Little Falls illustrates the rugged terrain encountered by the engineers as they negotiated the route of the Erie Canal through the area.

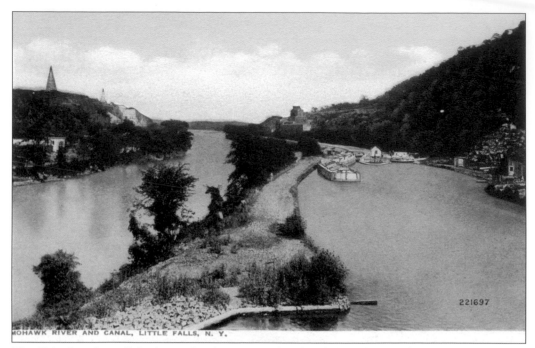

MOHAWK RIVER AND CANAL, LITTLE FALLS, N. Y.

221697

The Erie Canal parallels the Mohawk River and is divided by the canal's towpath. Boats are lining up to take their turn through one of several locks encountered at Little Falls. At the bottom of the picture is the point where a widewater area angles back to the typical 70-foot width of the enlarged canal.

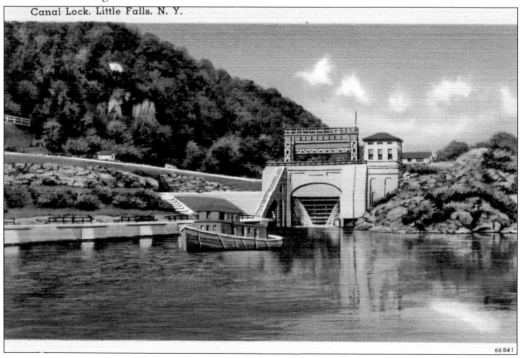

Canal Lock, Little Falls, N. Y.

66841

Lock 17E on the Erie barge canal was the highest lift lock in the world when built. It carried boats a bit over 40 feet in elevation and was a signature structure on the new canal system.

54

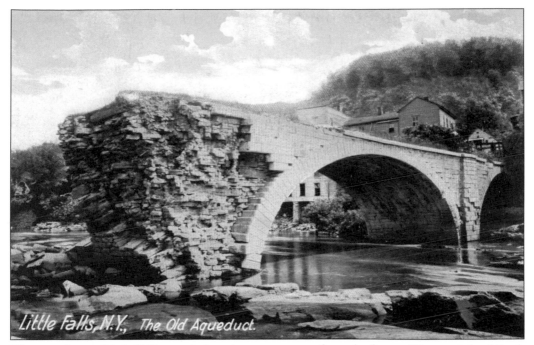

Little Falls, N.Y., The Old Aqueduct.

The aqueduct at Little Falls was designed to carry water from the former Western Inland Lock Navigation Company locks to the Erie Canal. The aqueduct remained operational as a water source until 1881 when a system of reservoirs negated the need to bring water from the river.

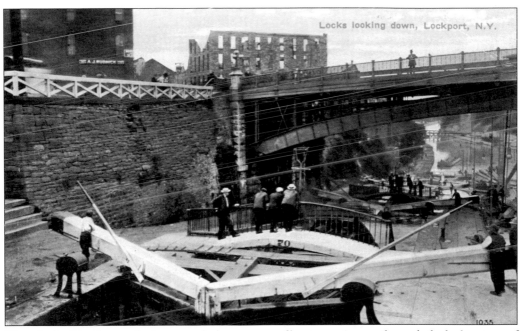

Locks looking down, Lockport, N.Y.

Here the lock tenders and others watch the progress of boats moving up through the lock system of the Erie Canal. At a minimum of 15 minutes per lock, it would take the boats at least 75 minutes to negotiate the five locks. This essentially guaranteed a layover at Lockport that became famous as an overnight community, with the taverns and breweries to prove it.

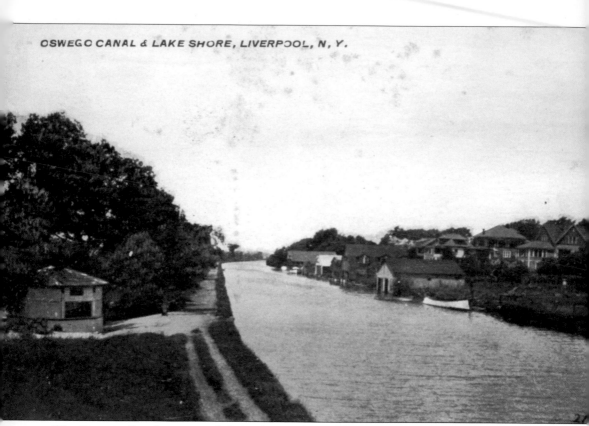

The Oswego Canal was routed along the north side of Onondaga Lake to take advantage of the massive salt industry at Syracuse. Over 10,000 acres were dedicated to refining the briny water found in ponds around the freshwater lake. The salt was brought to the surface by a series of underground streams. It was then either boiled or evaporated in solar vats to extract the mineral. The final product was then shipped out on both the Erie and Oswego Canals.

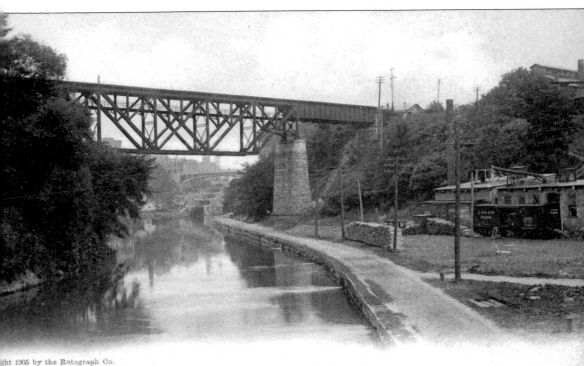

5633 N. Y. C. R. R. Bridge, Lockport, N. Y.

The State of New York owned the Erie Canal and made millions of dollars on the cargo shipped. One regulation that the state imposed with the intent of curbing competition was that any bridge that crossed the canal was required to be within a certain height of the canal surface. This was done to make it difficult for the railroad to cross the state and thus compete with the canal. When the New York Central Railroad tried to build a trestle bridge across the canal at Lockport, the span between the water surface and bottom of the bridge was too great. So the railroad engineers flipped the bridge's structural elements upside down. This solution just cleared the maximum distance allowed and infuriated the state legislature, which was powerless to stop the work.

Nathaniel Roberts was given the task of finding a solution to circumventing the 70-foot-high Niagara Escarpment. This wall of limestone that keeps much of the Great Lakes in place and that is being continually cut through by Niagara Falls was a geologic nightmare for the canal engineers. To reach Buffalo, they had to bring the Erie Canal down off the escarpment, and the lock technology at the time simply was not designed to cope with a sheer wall of stone. Roberts's solution was to divert a local creek into a raceway and build a double flight of five locks into the abandoned waterfall, the shape of which provided the perfect template.

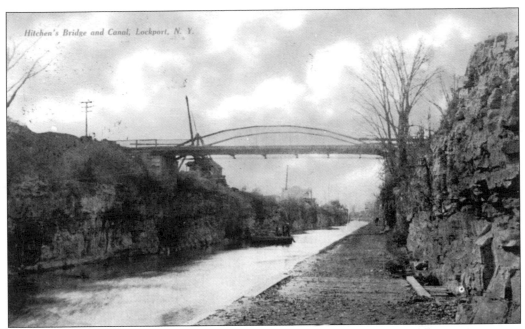

Once the rise at the Niagara Escarpment was overcome, the engineers' next challenge was to blast through three miles of the escarpment. In some places, they needed to blast down 23 feet. This required not only blasting for the Erie Canal's chamber but also for the towpath.

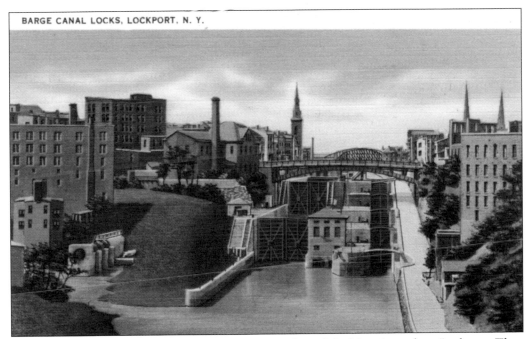

When the Erie barge canal was built, the engineers adapted the historic works at Lockport. They removed the south set of locks and built two 30-foot lifts in their place. They retained the north set of locks and used them to flush excess water from the barge locks.

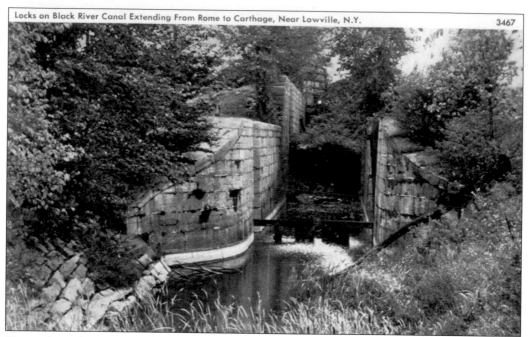

Locks on Black River Canal Extending From Rome to Carthage, Near Lowville, N.Y.

3467

Pictured are the remains of a lock on the Black River Canal near Lowville.

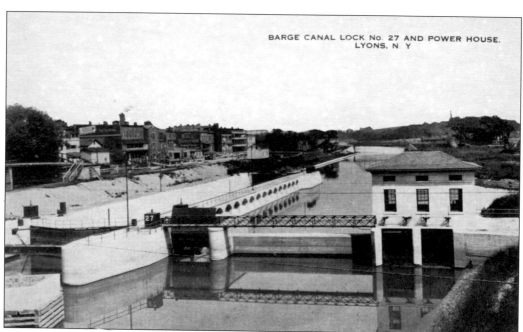

BARGE CANAL LOCK No. 27 AND POWER HOUSE.
LYONS, N Y

Here is the lock and powerhouse of lock 27 at Lyons. The Erie barge canal is incorporated into the Clyde River. The old Erie Canal prism is to the far left.

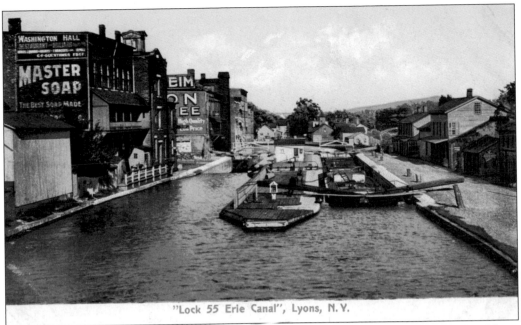

"Lock 55 Erie Canal", Lyons, N.Y.

This image of lock 55 at Lyons is typical of the canal locks on the Erie. The cluster of buildings taking advantage of the boat crews and passengers as they pause to negotiate the locks is a common scene.

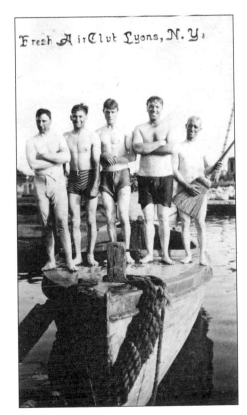

This group, calling itself the Fresh Air Club, is seriously taking its chances swimming in the Erie Canal. Restrooms on the canal boats consisted of a bucket. Passengers and crew were encouraged to flush the bucket out in the canal after use. With over 4,000 boats using the canal, the canal could never have been considered clean.

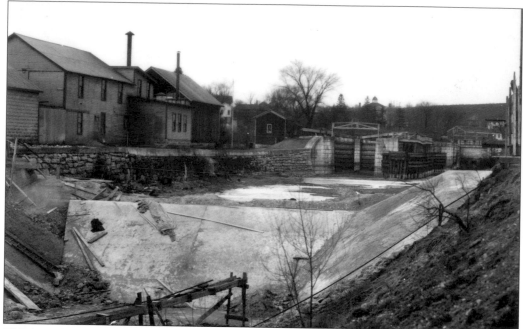

This is an image of the spillway on the bypass for the New York State Barge Canal at Macedon. The image looks west and was taken on February 6, 1919, as part of the survey work for the barge canal.

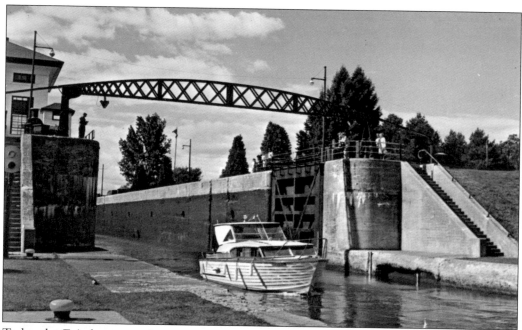

Today the Erie barge canal system caters to pleasure boats. The recent federal designation of the New York State Barge Canal as the Erie Canalway National Heritage Corridor provides the entire extant canal system with a designation on par with a national park. The mandate of increasing and promoting tourism on the canal has had a tremendous positive impact on the use of the system.

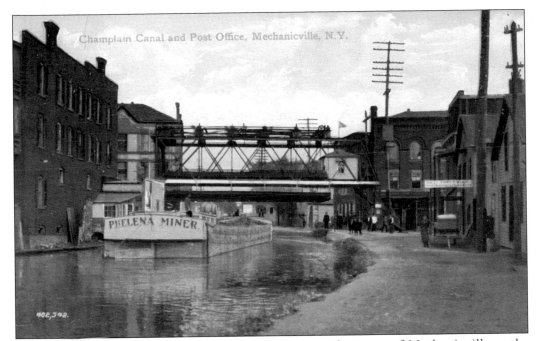

The boat *Phelena Miner* moves under a lift bridge in the town of Mechanicville at the Champlain Canal.

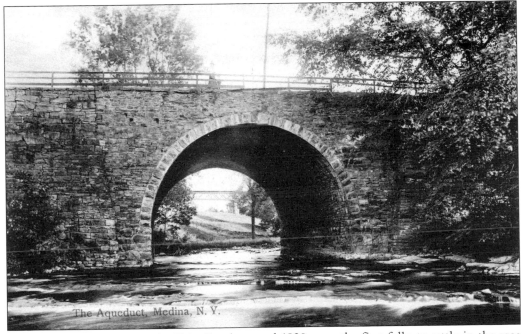

The laborers constructing the Erie Canal around 1820 were the first folks to settle in the area that was to become Medina.

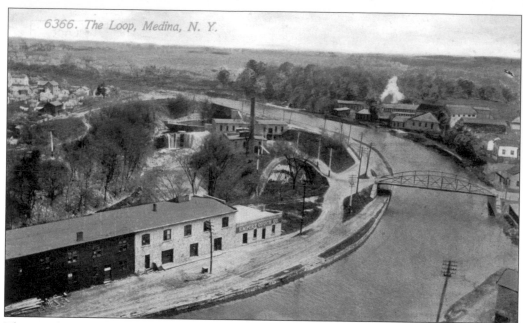

The aqueduct at Medina was designed to carry the canal over Oak Orchard Creek. The aqueduct can be seen in the other image of Medina on page 63. In this image, it is located on the inside of the bend at the point were the Erie Canal begins to disappear from the picture plan. A cascade of water marks its location.

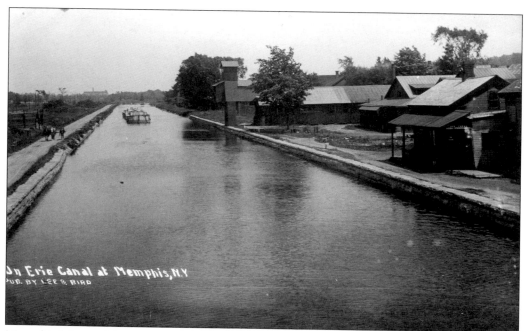

Memphis is located between Jordan and Warners in what was part of the middle division of the Erie Canal administrative hierarchy. Here a pair of canal boats is entering the town from the west. The team pulling the boats is visible on the towpath about 200 feet in front of the boats.

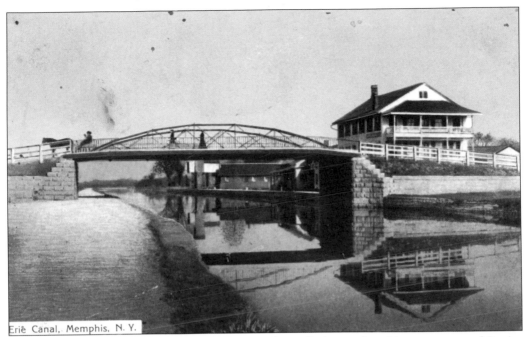

Erie Canal, Memphis, N. Y.

This image is of a Whipple Bowstring Truss Bridge, a design perfected by a man named Squire Whipple. Whipple designed and patented the bridge design in 1840, and its simplicity made it a natural for use on the Erie Canal.

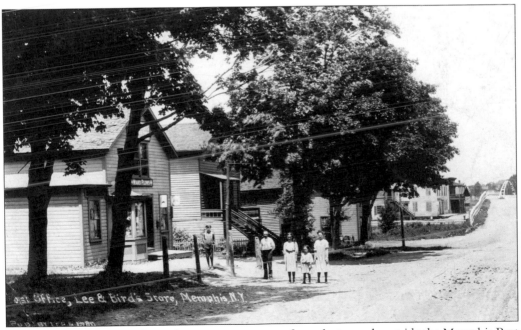

Post Office, Lee & Bird's Store, Memphis, N.Y.

This family of four has taken a few moments to pose for a photograph outside the Memphis Post Office. The Erie Canal is behind the family where the road rises and meets the bridge truss.

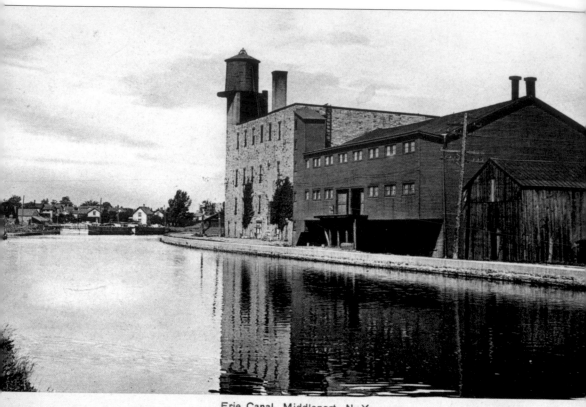

Erie Canal, Middleport, N. Y.

The Erie Canal was famous for immigrant and passenger travel. However, this part of the history was only to last from 1825 until about 1850. By the early 1850s, the railroads gained the ability to ship across state during the canal season. This marked for all intents and purposes the end of the Erie Canal. Unable to compete for passengers, the packet boats disappeared, and the cargo boats were relegated to carrying bulk materials that the railroads did not like to deal with, such as coal and lumber. The canal revenues slowly declined, except for a brief spike during the Civil War, and by the late 1890s, the state was seriously debating what to do with the canal. The slow decline ended in the fall of 1917 when the state officially closed and abandoned it.

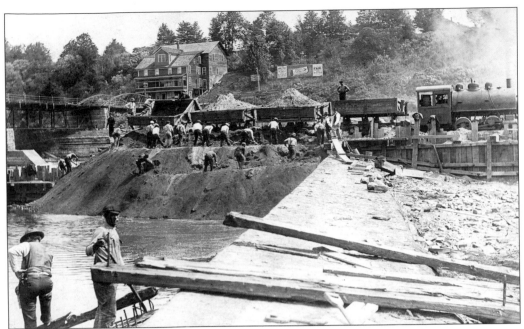

Crews are busy constructing the dam in the Oswego Canal, which became part of the Oswego barge canal system. The train is bringing fill to the work site. The earth is dumped from the hinged cars and then formed by the crews.

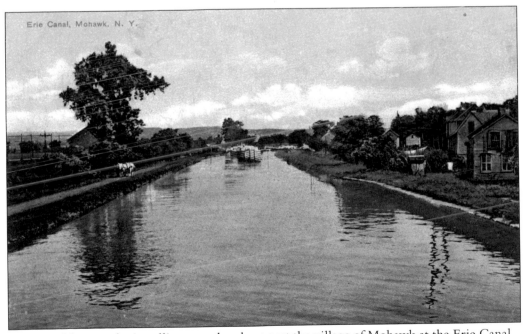

A team of three mules is pulling a tandem boat past the village of Mohawk at the Erie Canal.

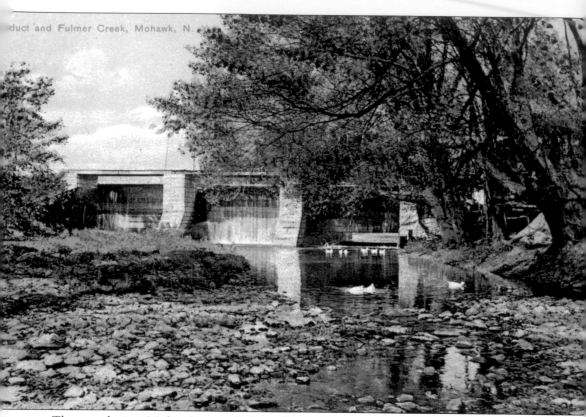

The aqueduct at Mohawk spans Fulmer Creek. The supporting members of the Erie Canal aqueducts were constructed of ashlar cut stone. A wooden trough constructed of white oak was then built inside the supports to carry the canal. In this image, the trough is visible between the arches. The water flowing down the sides is coming from the waste weirs at the top of the canal, which were used as overflow for the excess water.

Three

MONTEZUMA
THROUGH WHITEHALL

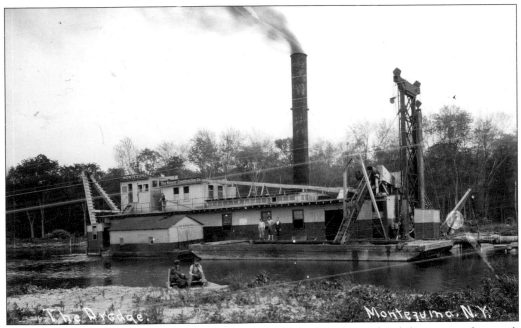

The advantage of the Erie barge canal over the old Erie Canal was the ability to use the state's natural waterways. To do this, the rivers and lakes were dredged. Here the *Montezuma*, a massive coal-fired suction dredge, literally chews the river into a canal with a set of cutting heads suspended under the triangular-shaped hoist on the left.

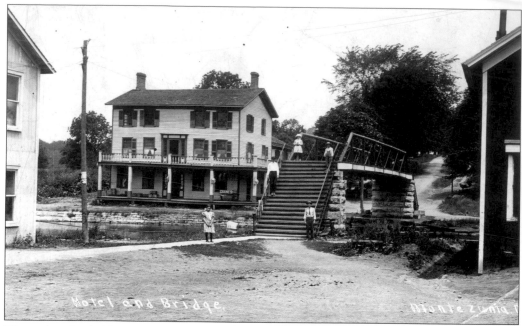

The pedestrian bridge was a common sight on the Erie Canal. Over 300 bridges spanned the original 1825 Clinton's Ditch. Many of the bridges were built to connect farmlands that had been bisected by the canal. The building across the canal with the porches is Cranes, a tavern that, according to the small sign on the wall, carried Iroquois beer.

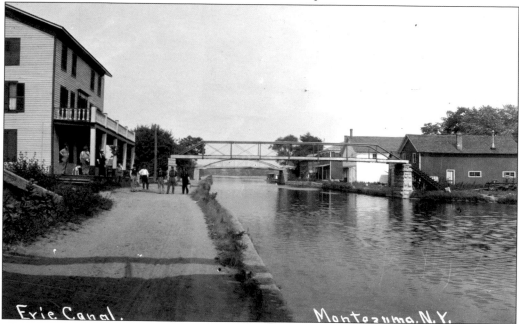

This image shows the same pedestrian bridge from the prior image as seen from the towpath. Note the bridge just down the canal from the pedestrian bridge. The abutment is sloped, indicating that the bridge is designed for carts and animal teams in addition to pedestrians. Also visible is how the bridge abutments on the towpath side are built back from the Erie Canal bank. This allowed the towpath to continue unobstructed under the bridge.

The original Erie Canal was cut through the Montezuma area between 1820 and 1821. The Erie Canal produced many myths. One of the most misunderstood aspects of the canal is the rate of deaths of workers. It was rumored that 1,000 workers died while constructing the section through the Montezuma Marshes. In fact, the workers only became sick from what was likely malaria, and once the malaria season was over, work resumed. However, Gov. DeWitt Clinton and his wife, Ann, toured the area. She contracted malaria and died soon after.

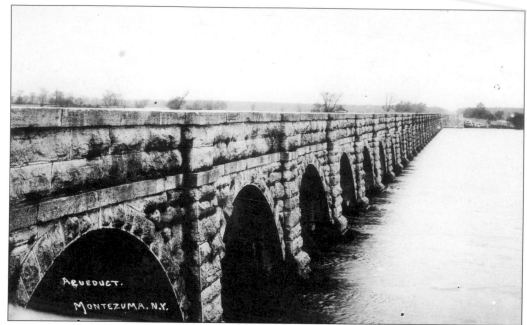

The Richmond Aqueduct carried the Erie Canal across the Seneca River at Montezuma. The state dynamited most of the aqueduct while building the barge canal system. The state had little option, as the new canal was built directly in the river, and there was no way for the boats to navigate between the stone arches.

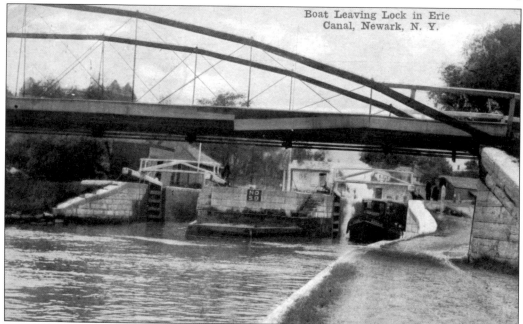

A small tug is seen leaving lock 58 of the Erie Canal at Newark. Motorized boats were allowed on the canal system; however, their speed was greatly restricted due to wake damage to the canal's earthen walls. The stonework along the canal edges in this image is an extension of the lock structure. As the canal enters the rural setting, the wall was replaced by a sloped clay and rubble wall.

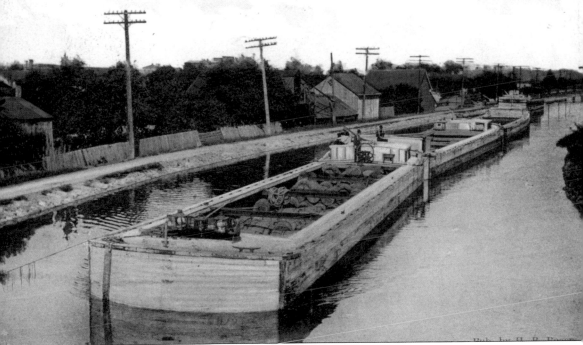

Doubled boats on the Erie Canal were a common sight. This image shows an uncommon sight of three boats coupled together. There is a fourth boat in the distance that is actually facing the opposite direction and is not part of the grouped boats. The connection point of the towrope is not on the front of the boat but is about a third of the way down the side. This offsetting of the rope helped to control the steering. Attaching the rope to the tip of the boat had the effect of causing a hard pull toward the shore.

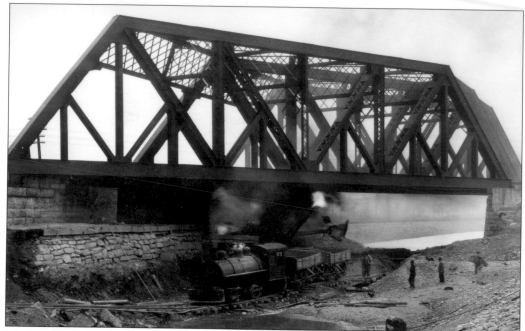

The New York State Barge Canal is being excavated east of Newark. The bridge is for the New York Central Railroad. The image was taken on April 16, 1918, by the New York State Department of Engineers.

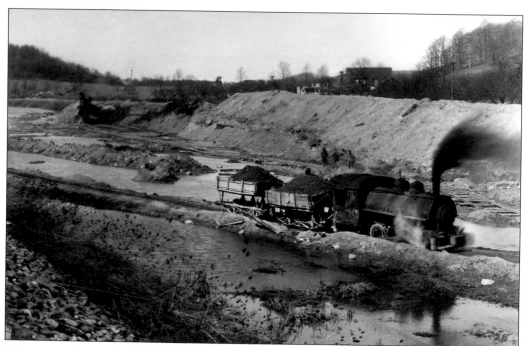

This image shows the excavation of the site for what will become lock 28A of the New York State Barge Canal. An excavator can be seen in the background. The excavator loads the fill into the carriers on the train that then hauls the fill away from the site.

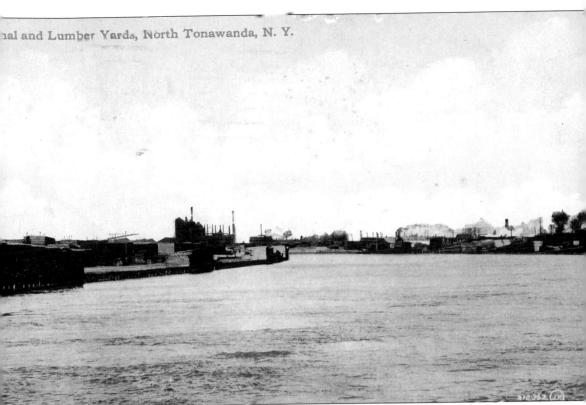

Pictured are the coal yards and lumberyards found in North Tonawanda. After 1850, the railroads were able to dominate the shipping in New York State. For all intents and purposes, this proved to be the end of the Erie Canal. However, the end was slow in coming. The canal continued to function until 1917, when it was closed and abandoned by the state. During this period, the canal was relegated to hauling bulk materials the railroad companies did not want to deal with. Two prime examples of this were coal and lumber.

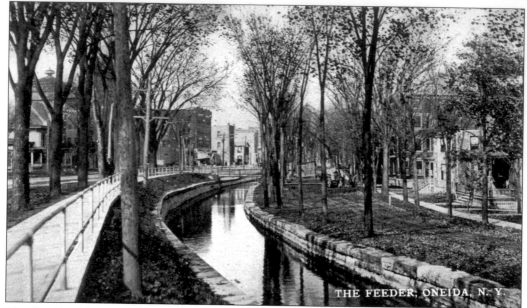

THE FEEDER, ONEIDA, N. Y.

The Oneida Lake Company wanted to build a navigable canal between the lake and Higgensville, but the issue of where they would draw the water to supply the canal was a stumbling block. The state required that to use water from the Erie Canal to supply the proposed Oneida Lake Canal the company would need to replace an equal part of water back to the Erie as was taken from it.

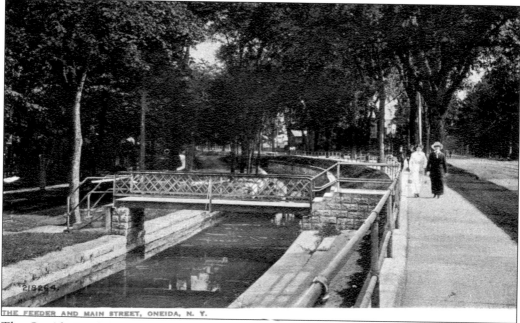

THE FEEDER AND MAIN STREET, ONEIDA, N. Y.

The Oneida Feeder became the compromise and was designed to route an equal amount of water back to the Erie Canal to replace that used by the Oneida Lake Canal. The feeder was never able to replace the amount of water being used from the Erie, and so the operation was eventually taken over by the state. The Oneida Lake Canal was bogged down in both technical and legal issues from the beginning and was never a viable canal.

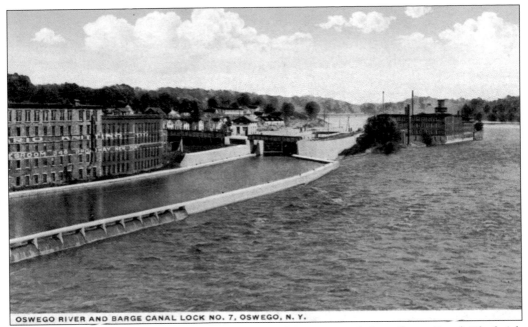

OSWEGO RIVER AND BARGE CANAL LOCK NO. 7, OSWEGO, N. Y.

Pictured is lock O7 on the Oswego River section of the New York State Barge Canal. The brick building in the center of the river is a hydroelectric plant that is working symbiotically with the barge canal to produce electricity.

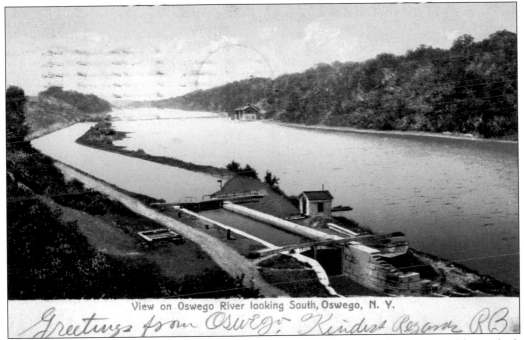

View on Oswego River looking South, Oswego, N. Y.

This image is looking south, or upriver, toward Syracuse. It shows the upper and lower lock pools, the small lock tender's shanty, the towpath, and the berm or heelpath that separates the Oswego Canal from the river.

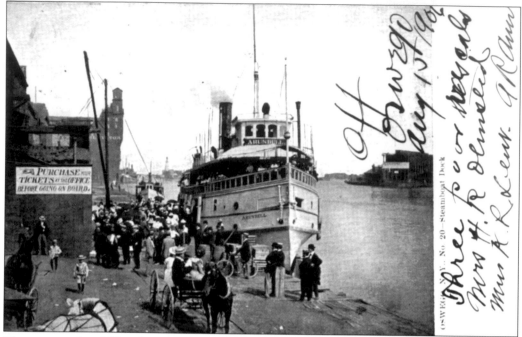

The steamer *Arundell* is taking on passengers for a trip out of the Oswego Canal and harbor onto Lake Ontario. In addition to passengers, grain was a major commodity that was transitioned either to or from the canal system. As testimony to this, a massive grain elevator sits at waterside in the distance behind the *Arundell*.

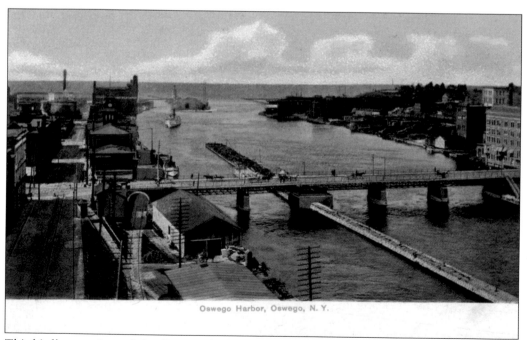

Oswego Harbor, Oswego, N. Y.

This bird's-eye view of the Oswego harbor illustrates how everything comes together at this major port. Lake Ontario dominates the horizon, a rail track cuts its way between the buildings, and the mouth of the Oswego Canal is sandwiched between the river and the warehouses.

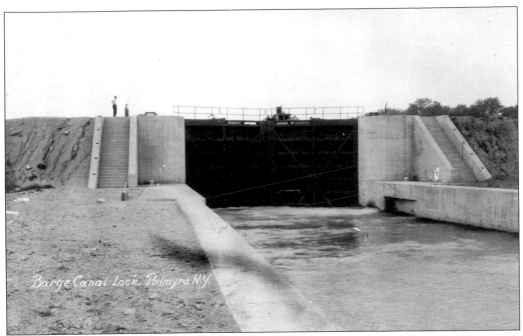

The town of Palmyra is located a few miles east of Rochester. The Erie barge canal parallels Route 31 and follows almost precisely the former Erie Canal. Pictured is lock 29 as it looked when newly completed.

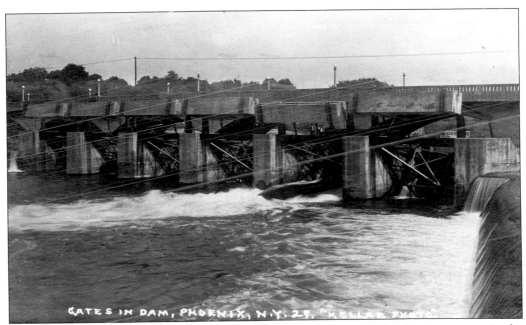

The Taintor gates in Phoenix help to control the water level during the shipping season. In the winter, the gates are raised, and the water is allowed to flow naturally. To the right is the spillway for lock O1 (the O designates Oswego Canal) at the Oswego barge canal.

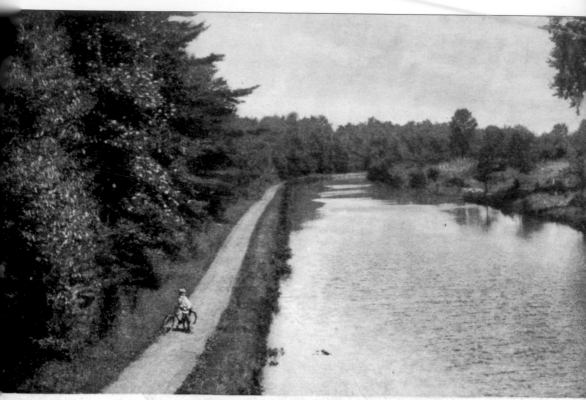

SCENE ON THE OSWEGO CANAL

C. E. & E. Co., Syracuse, N. Y.

Pictured is the Oswego Canal and towpath north of Syracuse but prior to the point where the canal begins to parallel the Oswego River. Today, like the boy in the image, bikers continue to enjoy riding on the towpath. The state maintains a 40-mile section designated as a state park between Dewitt and Rome. Additional trails are found throughout the state along the former canal lands.

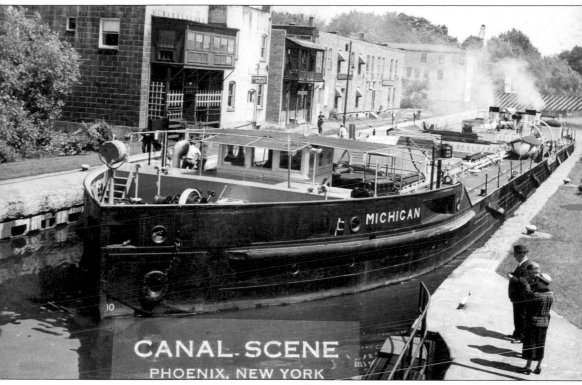

CANAL SCENE
PHOENIX, NEW YORK

The barge *Michigan* squeezes through lock O1 at Phoenix. For all the modern equipment and advances, it is wonderful to note the kerosene lamp on the boat, located just behind and above the name Michigan on the side of the boat. The arrangement of a kerosene lamp set into a recess in the side can be found on boats throughout the early Oswego barge canal days and, of course, was a carry over from as early as the first boat on Clinton's Ditch.

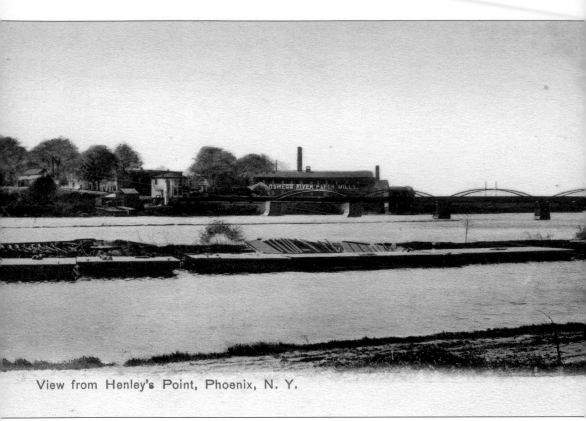

View from Henley's Point, Phoenix, N. Y.

This image was taken from Henley's Point near the town of Phoenix on the Oswego Canal. The

Oswego River flows by the outside of the berm just past the moored barge.

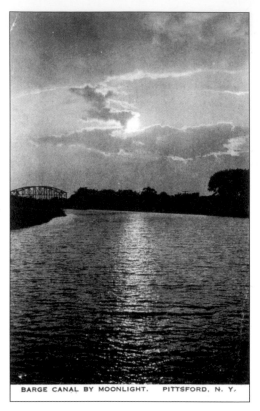

BARGE CANAL BY MOONLIGHT. PITTSFORD, N. Y.

Pittsford is located a few miles south and east of Rochester. This image was taken in 1921, three years after the new canal opened statewide. At that time, the New York State Barge Canal principally catered to cargo, and passenger travel was minimal. Today that role is reversed, and the canal is primarily a tourism machine. The viability of today's canal system as a tourism destination is greatly enhanced by the efforts of the Erie Canalway National Heritage Corridor Commission.

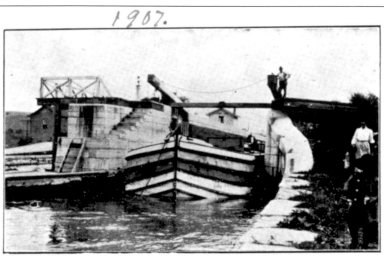

1907.

PORT BYRON LOCK---GOING OUT

Today the remains of lock 52 of the Erie Canal at Port Byron are highly visible. They sit on the south side of the New York State Thruway as a reminder of the evolution of transportation in the state. The portion of the lock still visible from the thruway is shown on this postcard. The Canal Society of New York State is currently involved in a major restoration project at this site.

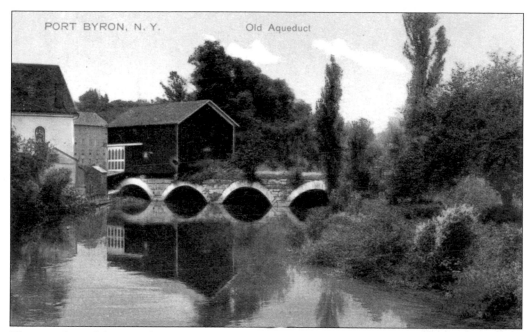

PORT BYRON, N. Y. Old Aqueduct

The remains of the aqueduct spanning the creek of the Erie Canal have been retrofitted as a stable foundation for a barn. While there are many examples of canal aqueducts that continue today as foundations for roads (Rochester and Syracuse are prime examples), it is much more rare to find them used to support a building.

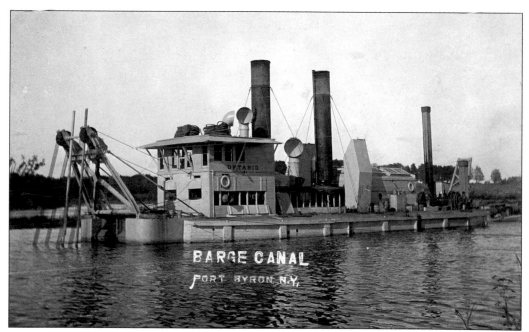

The dredge *Ontario* clears the bottom of the Seneca River near Port Byron during construction of the New York State Barge Canal. These massive coal-fired dredges were so expensive that the state mandated they be run 24 hours a day seven days a week to keep them profitable.

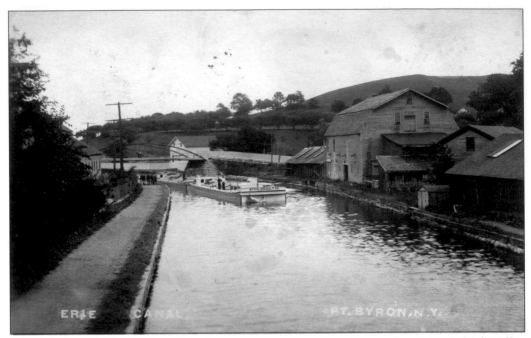

A boat owned by the Sterlung Salt Company moves past a coal barn advertising Lehigh Valley (Pennsylvania) Coal. Even in the years following the railroads' supplanting of the canal system, the Erie Canal continued to be a hallmark for successful nationwide shipping.

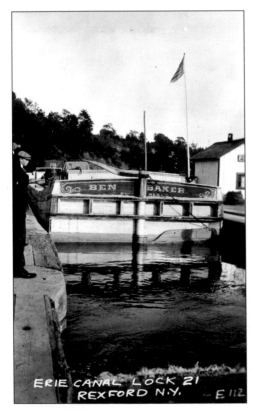

The boat *Ben Baker* of Buffalo makes its way through lock 21 of the Erie Canal at Rexford. The rudder has been chained flush to the stern of the boat and is being pulled out of the lock without the services of a steersman. The rudder was tucked away to allow the boat to completely fill the lock chamber. The narrow confines of the lock made it possible to pull the boat without steering.

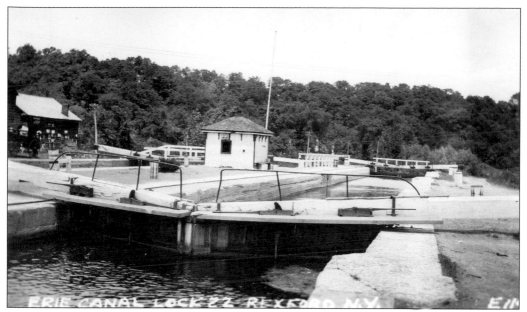

Pictured here are the locks, lock gates, tender house, and a general store at lock 22 of the Erie Canal at Rexford.

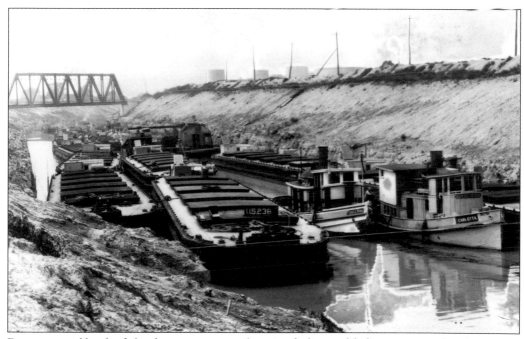

Barges owned by the federal government and a pair of what are likely state-owned tugboats wait at the west guard lock of the New York State Barge Canal on May 27, 1919, near Rochester.

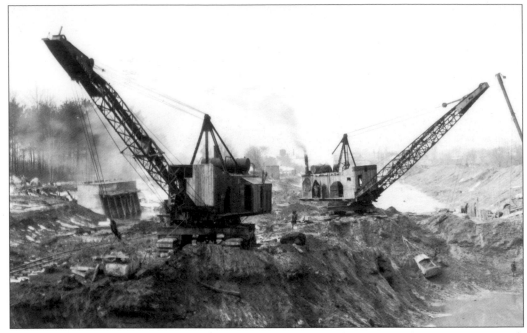

This image is of some of the last major excavation work on the New York State Barge Canal. The image was taken on March 13, 1918, near Rochester west of the Erie Railroad. In May 1918 at Rochester, a ceremony was held to cut the last remaining section of canal, opening the system to statewide operation.

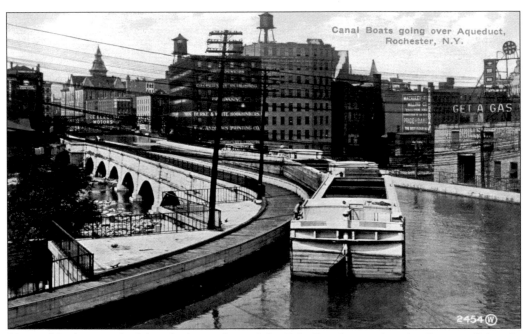

Pictured is the wonderful arched aqueduct of the Erie Canal spanning the Genesee River in Rochester. The aqueduct is still in use today. It supports Broad Street as the road passes over the river into downtown.

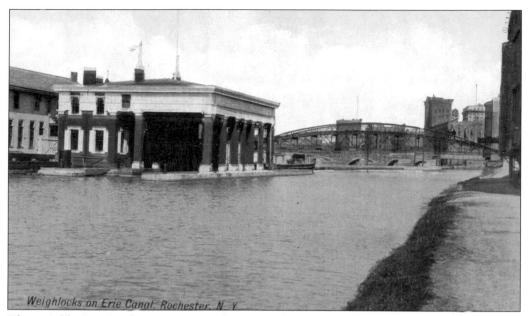

The weighlock at Rochester was one of seven on the Erie Canal system. They were all built to reflect the Greek Revival style of architecture popular with government structures in the middle part of the 19th century. The style was evocative of the new nation's pride in democracy and the basing of the American governmental system on the Greek democratic principals. Today the Rochester Public Library stands on the foundations of the former structure.

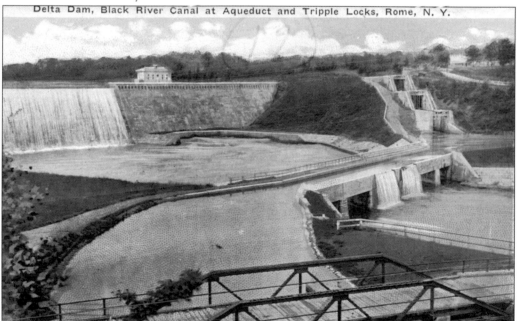

This image brings all the canal features together. Three locks bring the Black River Canal down the embankment alongside the dam. An aqueduct brings the canal across the Black River, while the waste weirs spill water into the river, maintaining the canal's water level. Finally the canal winds under a bridge and on toward its junction with the Erie Canal. Next to the spillway on the Delta Dam sits a powerhouse used to generate electricity for dam operations.

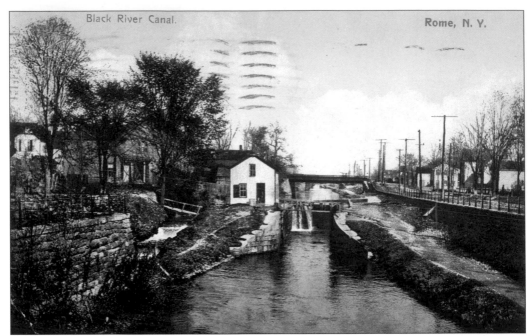

The Black River Canal was the major canal feeder into the Tug Hill region, located just west of the Adirondack Park.

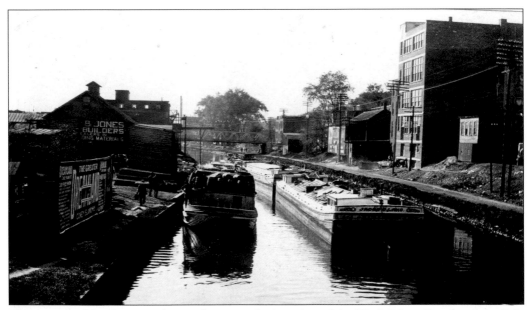

This image of the Erie Canal was taken near the junction of the Black River Canal and the Erie Canal in Rome. The smaller canal boat with the barrels on top was specifically designed for the Black River Canal. By contrast, the larger boat was designed for the Erie Canal. Erie boats were unable to enter the Black River Canal because they were too large to fit in the smaller locks.

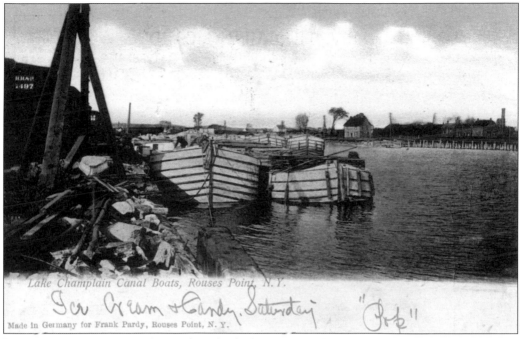

Rouses Point is located on the northern half of Lake Champlain. Here the canal boats are docked, waiting for cargo and passage by tugboat from the lake into the Champlain Canal system.

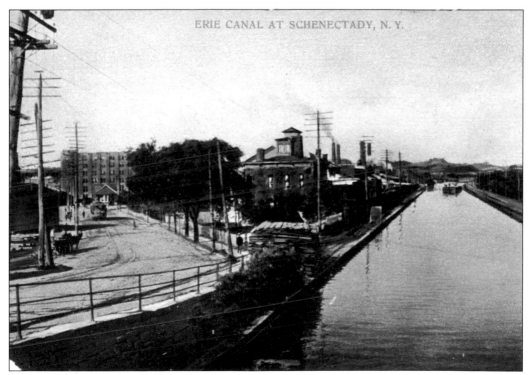

ERIE CANAL AT SCHENECTADY, N. Y.

Trolleys, horse-drawn carriages, and canal boats all work within their respective corridors in the town of Schenectady on the Erie Canal in this image from about 1905.

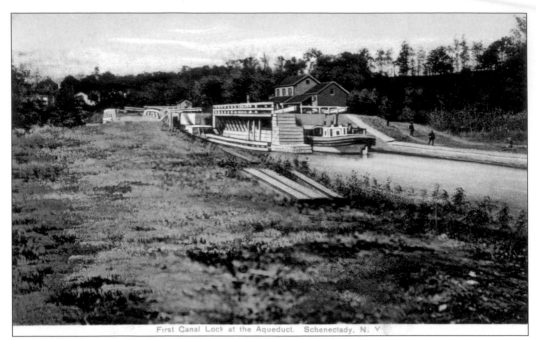

This 1908 image illustrates the step up in elevation required by the boats to maneuver onto the aqueduct to cross the Mohawk River. After navigating through the lock of the Erie Canal, the boats took a hard left turn and were on their way across to the north side of the river.

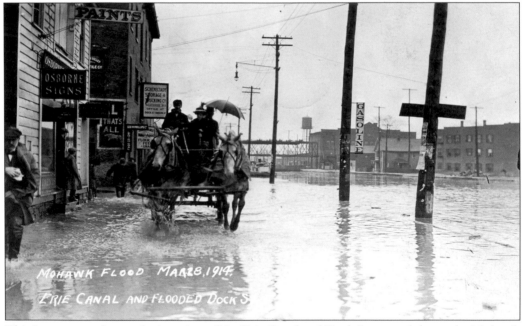

This image was taken at the junction of the Erie Canal and Dock Street and shows the Mohawk River in full flood. The image was taken on March 28, 1914, and typifies why the canal never opened until May. The amount of water that New York receives creates a wonderful environment for a canal; however, even with today's modern canal, it is simply impossible to control the amount of water in the early spring.

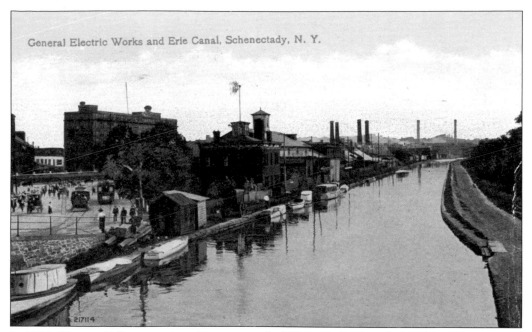

General Electric Works and Erie Canal, Schenectady, N. Y.

217114

In 1886, Thomas Edison purchased two vacant buildings on the site of what is now the General Electric plant at Schenectady, an area along the Mohawk River and Erie Canal that was part of the Mohawk Flats Wetlands. Prior to 1947, most of the wetlands were filled in by General Electric, and over 240 buildings were constructed.

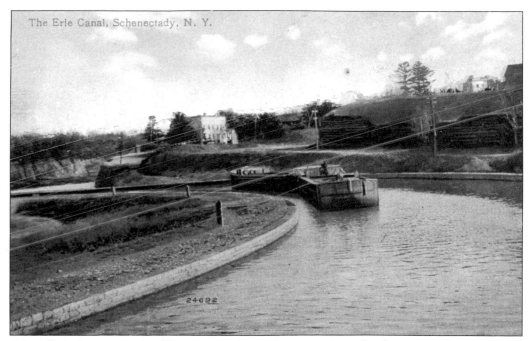

The Erie Canal, Schenectady, N. Y.

24692

A hoodledasher, or a pair of boats coupled together, negotiate a hard curve in the Erie Canal. At this point, they have crossed the Mohawk River and are entering Schenectady.

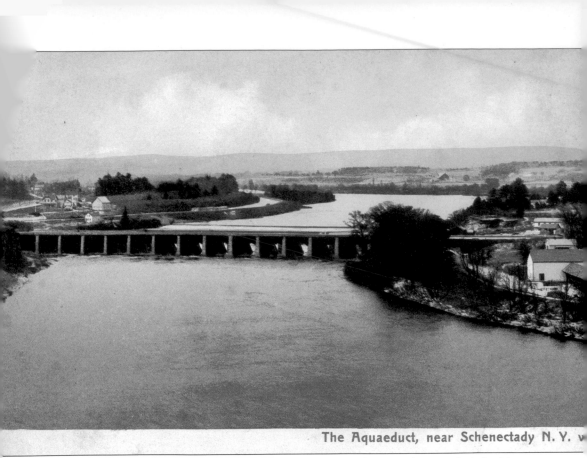

The Aquaeduct, near Schenectady N. Y. w

This bird's-eye view of the Upper Mohawk River Aqueduct at Schenectady is looking west to east along the Mohawk River. The aqueduct was built in 1842 and was one of two aqueducts in

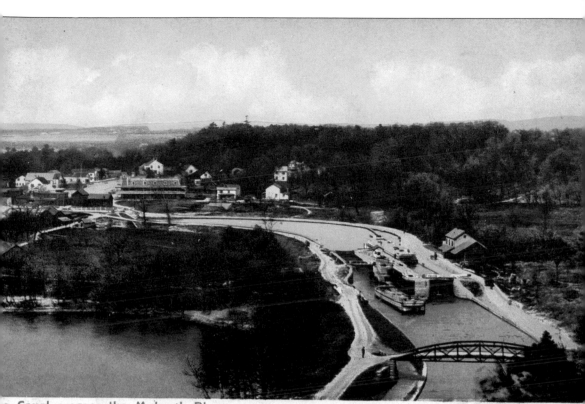

e Canal crosses the Mohawk River.

the area that crossed and then recrossed the river. The Erie Canal's other aqueduct was located at Crescent and was known as the Lower Mohawk River Aqueduct.

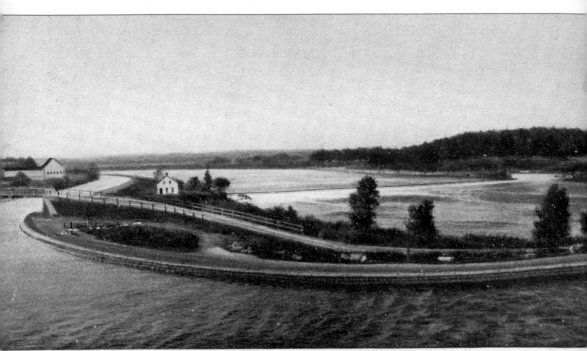

ERE THE ERIE CANAL CROSSES THE MOHAWK RIVER NEAR SCHENECTADY, N. Y.

In this image, the view of the Erie Canal is oriented looking south along the span of the Upper Mohawk River Aqueduct. At this point of the canal route, the terrain on the south side of the river heading east became geologically impossible. In 1820 and 1821, Canvass White, one of

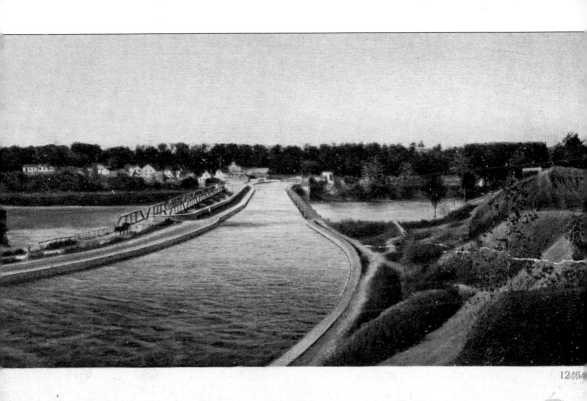

12464

the principal engineers on the canal project, proposed the crossing and recrossing to avoid the terrain. The structures built under White's plan were replaced in 1842 as part of the larger statewide canal expansion project.

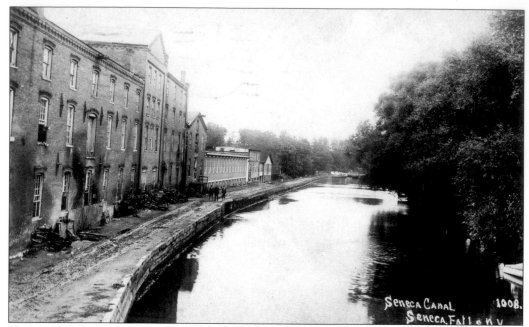

The Cayuga Seneca Canal replaced a small privately owned canal that was completed in 1821 by the Seneca Lock Navigation Company. The new state-owned canal opened in 1828 and became a vital water link between the northernmost points of Cayuga and Seneca Lakes.

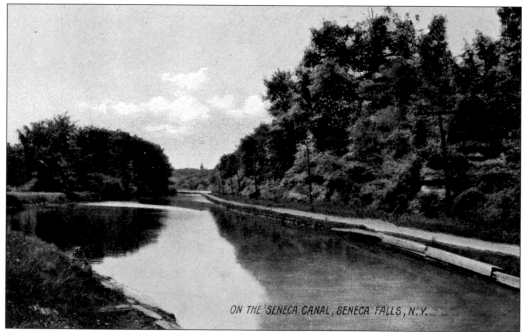

The Cayuga Seneca Canal was 21 miles long and contained 11 lift locks. The canal was located between the towns of Montezuma and Geneva and was the major transit point for goods being shipped south down the two lakes. The linking of the waterways was further extended by the Chenango Canal at Watkins Glen and the Crooked Lake Canal at Penn Yan.

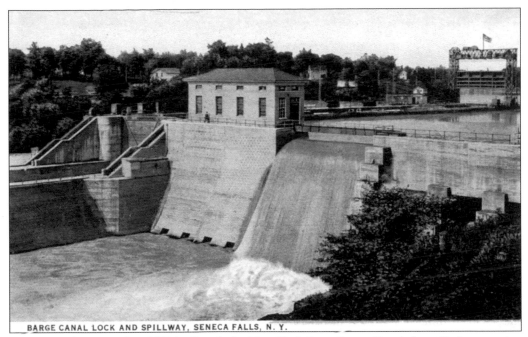

BARGE CANAL LOCK AND SPILLWAY, SENECA FALLS, N. Y.

Like its predecessor, the old Erie Canal, the New York State Barge Canal also relied on gravity, not pumps, to move the water through the locks. Here the lock is on the left side of the image, the hydroelectric power plant stands in the middle, and to the right is the spillway.

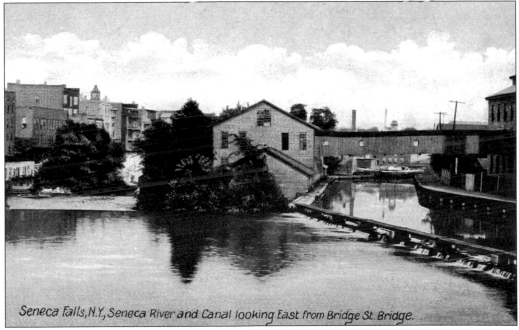

Seneca Falls, N.Y., Seneca River and Canal looking East from Bridge St. Bridge.

Here is an excellent example of regulating the water level in the Cayuga Seneca Canal. By building a berm between the canal bed and the Seneca River, the engineers were able to construct a number of waste weirs to drain the water at a specific level. In this image, the water is pouring from the canal into the river, indicating a perfectly working system to maintain the water level.

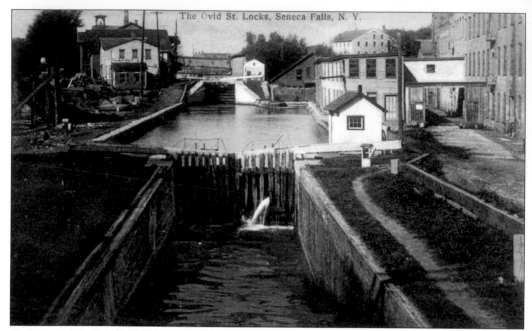

Shown are 2 locks of the 11 locks on the Cayuga Seneca Canal located at Ovid Street in Seneca Falls. The pool in between the locks has been designed as a widewater, or a wide point in the canal, where boats dock to either unload or wait their turn to pass through one of the locks.

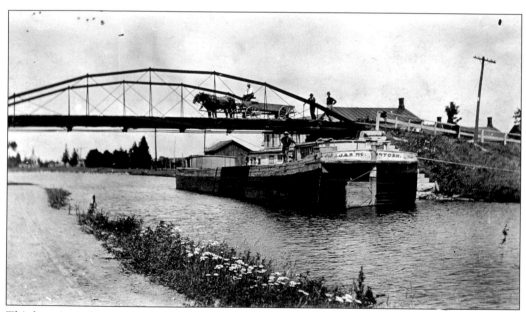

This boat is tied up near a bridge in the town of Starks Landing. The town is located south and east of Oneida Lake. The boat is empty, as evidenced by the large amount of it exposed above the surface of the water, the tiller is flush to the stern, and a line extends from the stern to the bank of the Erie Canal.

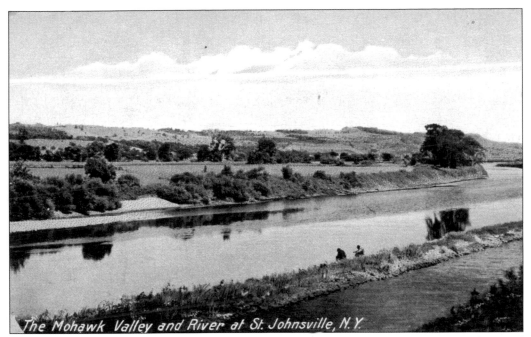

The Mohawk Valley and River at St. Johnsville, N.Y.

The Erie Canal parallels the north bank of the Mohawk River near St. Johnsville. This rural town was booming during the canal days. Lock 33 was located in the town, and it provided some commercial and retail opportunities for local residents. This image is indicative of the view of most of the rural parts of the canal.

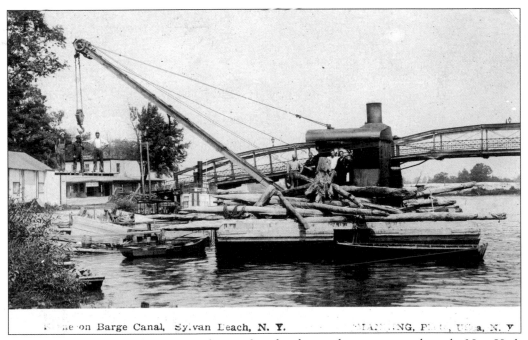

...e on Barge Canal, Sylvan Leach, N. Y. MANNING, PHOTO, Utica, N. Y.

In this image, a coal-fired steam winch is used to clear logs and stumps near where the New York State Barge Canal enters Oneida Lake at Sylvan Beach. The crew members were employees of the state. Their home administrative office was at the former Weighlock building in Syracuse.

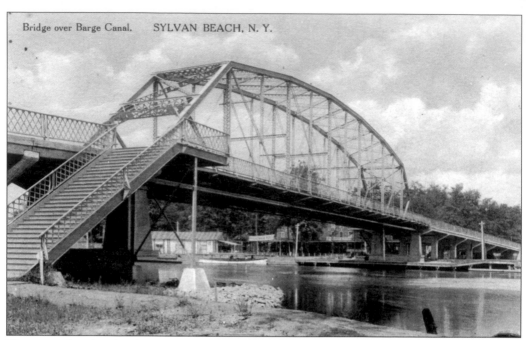

Here a pedestrian bridge is built alongside the main road bridge at Sylvan Beach. This was the eastern entry of the barge canal into Oneida Lake and remains a popular tourist destination today.

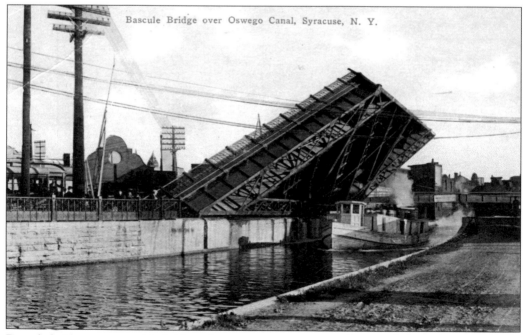

Bascule bridges are movable bridges that operate on a system of counterbalanced weights. Here a steam-powered canal boat glides under the raised bridge of the Oswego Canal at Syracuse.

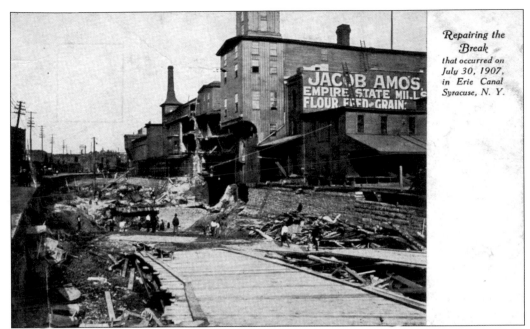

On July 30, 1907, a culvert that carried the canal over an underground tunnel at the Greenways Brewery collapsed. While there were no injuries, three boats were sucked into the void and smashed, and the pressure of the water flowing out of the Erie Canal tore the facades off the adjacent buildings.

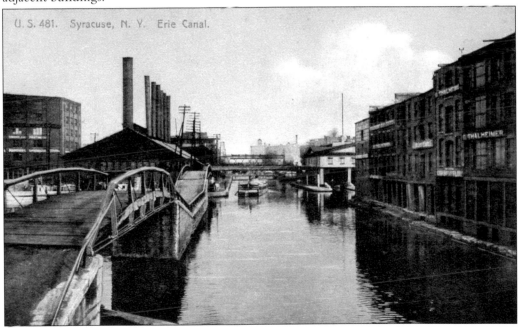

The pair of bridges on the left is the point where the Oswego Canal joins the Erie Canal. The Syracuse Weighlock building is the Greek Revival structure on the right side. Syracuse hosted one of the first weighlocks on the canal system. When tolls were abolished by the state in 1882, the Syracuse building had generated two thirds of the revenues raised by the seven weighlocks on the system.

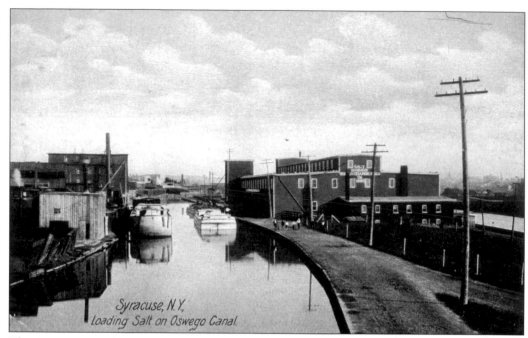

The Oswego Canal, built in the late 1820s, was designed to link the salt fields at Syracuse with the shipping on Lake Ontario. The salt production was a major economic engine for the area. What was to become Syracuse was only able to boast 600 people in 1800. By 1830, there was a city of 2,000, most of whom were dedicated to the production of salt.

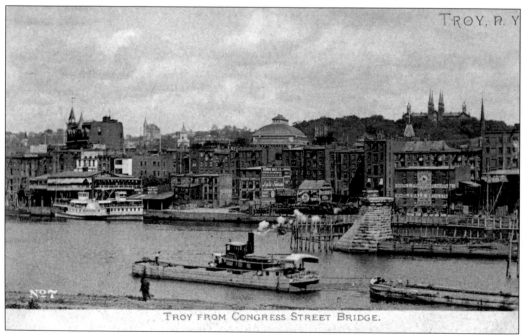

Canal boats are moved by tugboat north alongside the city of Troy. The tug is most likely moving the boats to a loading dock. Upon taking on cargo, the canal boats were moved to the side cut at West Troy and into the Erie Canal system.

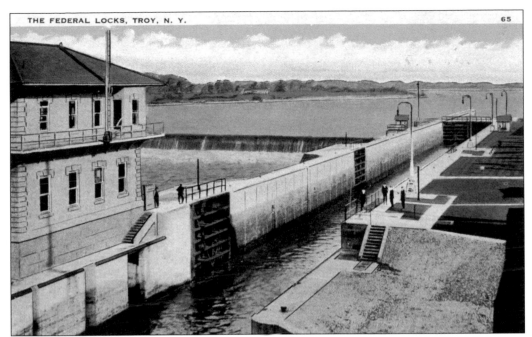

The federal locks mark the tidal head in the Hudson River. They are not part of the New York State Barge Canal system; rather, they are owned and operated by the federal government. It is, however, the first lock encountered on the canal system when heading north from New York City.

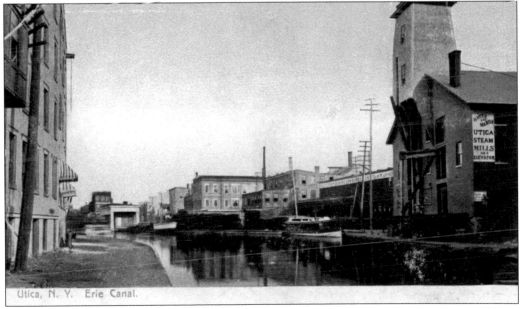

Utica, N. Y. Erie Canal.

Mills were a common sight on the Erie Canal system. While they were typically not able to use the excess canal water, they still located on the banks to take advantage of the direct access to shipping. The Hayes and Martin Mill is located just around the bend in the canal from the Utica Weighlock, seen in this image in the lower left at the canal bend.

This is a typical rural scene of the Erie Canal and towpath near Utica. The berm is overgrown, while the towpath remains crisp and clean, a product of the towropes and the attention of the canal staff that walked the towpath and tended to minor maintenance.

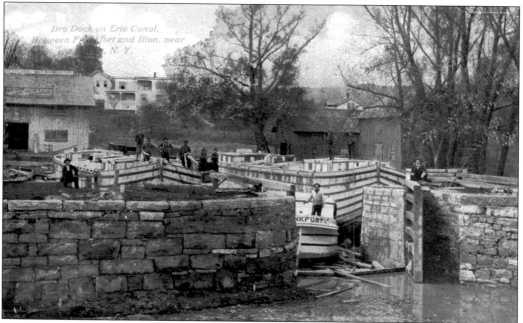

Dry docks were a common sight on the Erie Canal. The wooden boats required constant maintenance to ensure they were watertight and free of rot. Also, the boats had a useful life of about 10 years, at which point they were typically so deteriorated that they were abandoned and replaced with new boats.

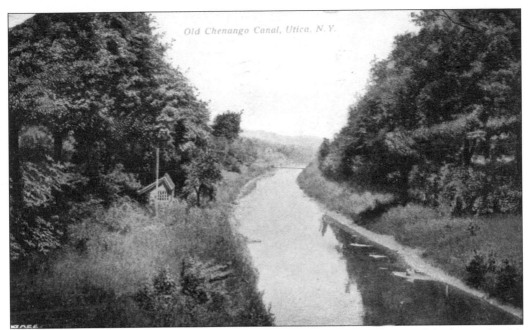

The Chenango Canal was a small, navigable feeder that linked the Erie Canal in the north with the town of Binghamton in the south.

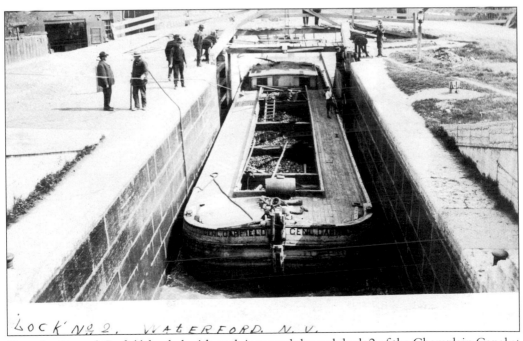

Here the *General Garfield*, loaded with coal, is moved through lock 2 of the Champlain Canal at Waterford. This lock has a lift of around 10 feet. (Photograph by George N. Michon.)

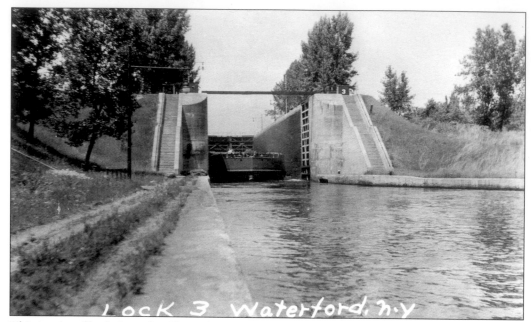

This image of lock 3 on the Champlain Canal at Waterford is a wonderful contrast in the size of the canal as compared to the prior image of lock 2 from the towpath era. Here the lock has a lift of approximately 30 feet.

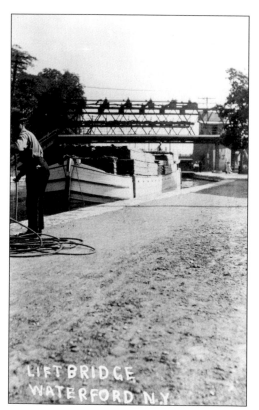

This rare image is of an African American man who is working with the boat's towrope. African Americans did find work on the Champlain Canal. However, the higher-than-normal wages and the cultural prejudices of the time relegated them to the lower-level opportunities such as unskilled dock work.

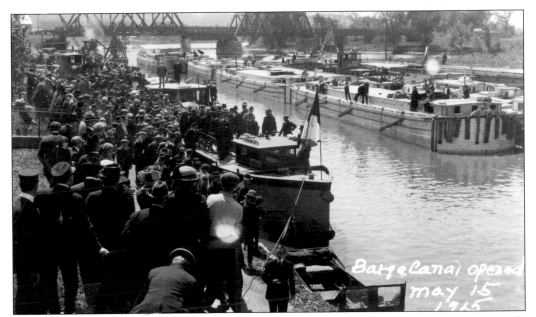

Barge Canal opened may 15 1915

Pictured are the opening ceremonies of the 1915 season for the Champlain barge canal. While the canal was not completed until 1918, like the construction of Clinton's Ditch almost 100 years earlier, the sections were opened as they were completed.

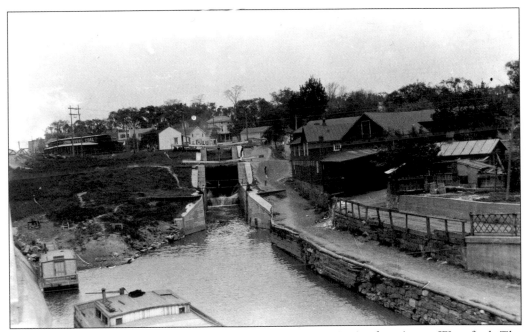

Here a pair of locks take the canal up part of the extreme rise in elevation at Waterford. The back end of a cargo boat is visible in the lower left of the image. The cargo boat dwarfs a small houseboat.

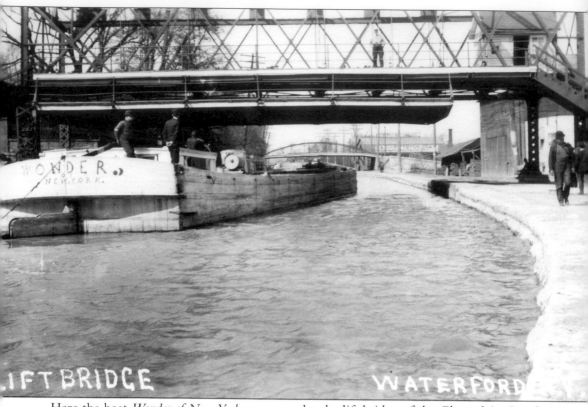

Here the boat *Wonder of New York* moves under the lift bridge of the Champlain Canal near Waterford. Note that in addition to the steersman controlling the rudder there is a steering wheel just in front of the rear cabin. The steering wheels were used when the boats were coupled in groups on the Hudson River. They were pulled by tugs, but because they were grouped into huge flotillas, the use of a rudder was not possible.

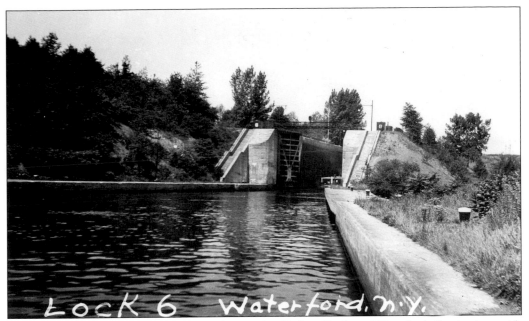

Lock 6 of the Champlain Canal is the last in the flight of locks at Waterford. Beginning with lock 2 on the system, the five locks at Waterford combine to lift the canal approximately 170 feet in elevation.

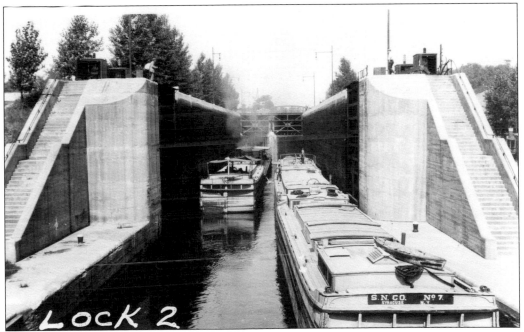

The locks on the New York State Barge Canal were designed to fit a maximum of six old towpath-era boats coupled together plus the tugboat to move them through the system. Here at lock 2, four converted towpath boats called consort barges are moved into the lock.

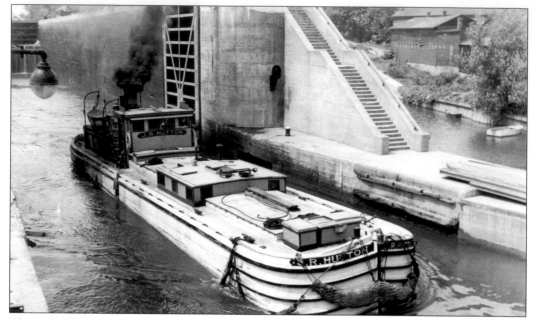

The *J. R. Hutton* is a former towpath-era cargo boat that has been converted for use as a tug on the new Champlain barge canal. The water on the far right is the former Erie Canal, the locks of which were bypassed by the barge canal but left intact.

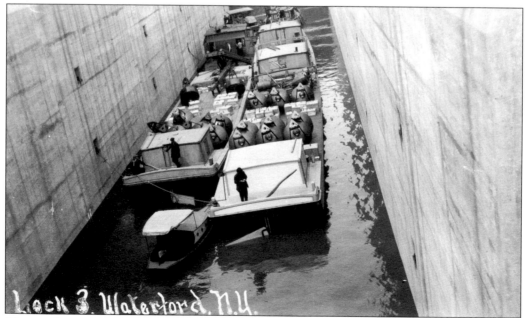

The two boats in lock 3 of the Champlain Canal at Waterford are loaded with buoys, lines, and weights. The boats are scows or state-owned work boats that are characterized by a flat, open cargo area between the two cabins.

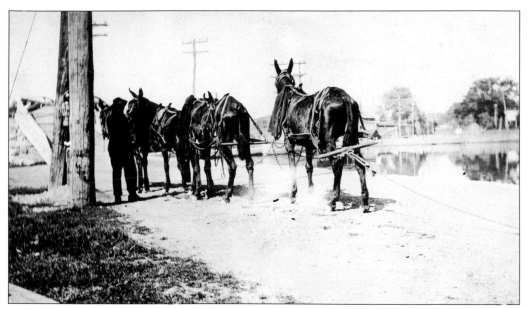

These four mules and their driver are pulling a canal boat on the Champlain Canal. While these animals are arranged in a straight line, configurations varied widely based on the number of animals used and the preference of the captain.

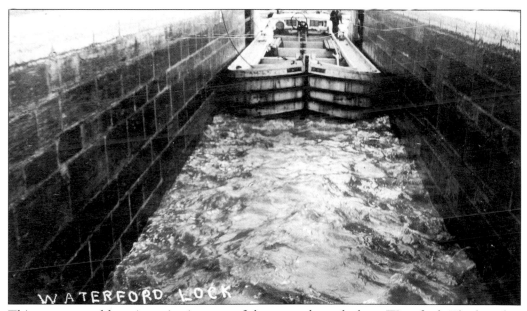

This empty canal boat is navigating one of the towpath-era locks at Waterford. The boat has just entered the lock; however, the roiling water suggests that the lock operator had not quite finished emptying the chamber.

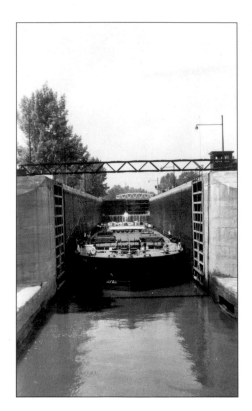

The oil barge *Green Island* completely fills this lock of the Champlain Canal at Waterford.

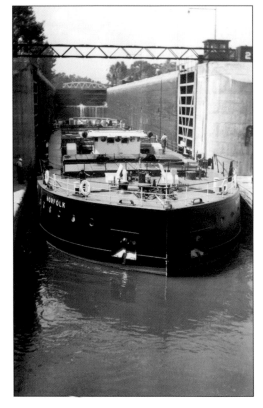

The boats that plied the barge canal system like the *Norfolk* were designed to have a maximum capacity of 2,000 pounds. By contrast, the towpath-era boats of the Erie Canal maxed out at 260 tons. In either case, the engineers precisely calculated the size of the canal prior to construction to ensure the maximum amount of cargo possible given a particular depth. The various barge canal depths were then extensively debated by the state legislature prior to approving 12 feet.

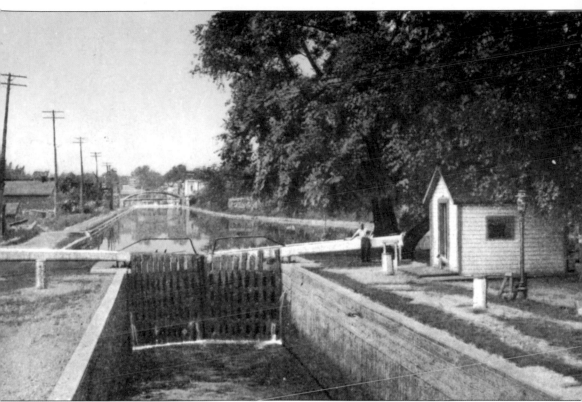

Here the lock tender leans on the beam of the gate outside the lock house of the Cayuga Seneca Canal. In the later part of the 1800s, the lock tenders developed a serious reputation for graft. The problem typically revolved around lock tenders requiring payment to lock the boats through. The problem got so bad that the state actually sent agents into the field to identify and punish the offending lock tenders, and stiff penalties were enacted by the state legislature.

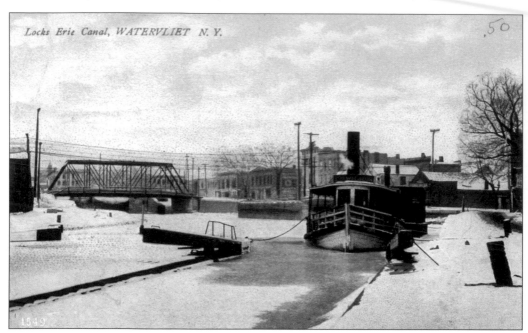

The boat *C.G. Witbeck* is going to have a long wait for the locks of the Erie Canal to open. This image, taken at Watervliet near Albany, is typical of a New York winter. The canal season typically closed in late November and opened again in late May after the flooding receded and the water levels in the canal could be consistently maintained.

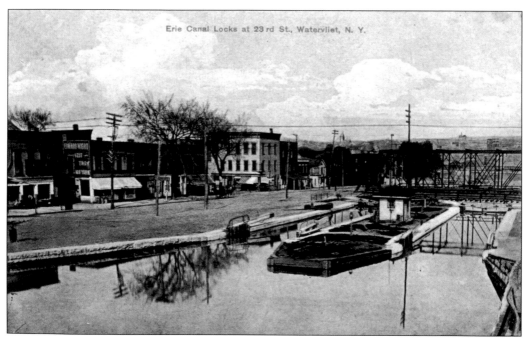

The locks in Watervliet during the summer are much friendlier for boat traffic along the Erie Canal, as opposed to the scene in the prior image.

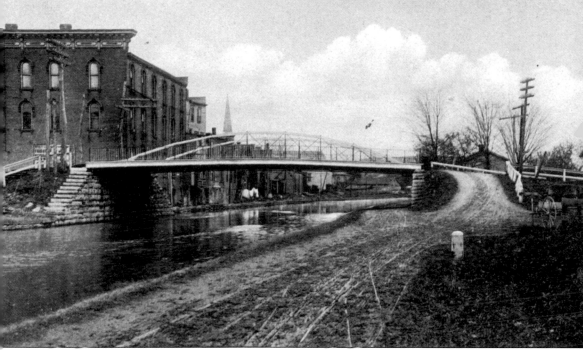

Canal Bridge at Brutus St., Weedsport, N. Y.

Located about 25 minutes west of Syracuse by car, Weedsport was one of several small canal towns that dotted the map. The bridge was designed to allow the towpath to extend under the abutment and allow an unimpeded path. Also, a road extends from the bridge to the towpath. This must have been designed to serve a local need, for instance, access to the building to the extreme right because the state strictly enforced a ban on any driving, other than boat teams, on the towpath of the Erie Canal.

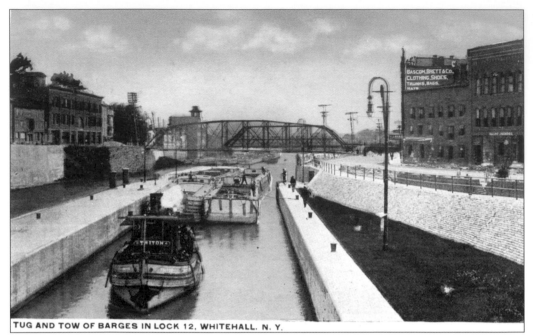

TUG AND TOW OF BARGES IN LOCK 12, WHITEHALL, N. Y.

The tug *Triton* pulls a group of consort barges (former towpath canal boats converted for use on the Champlain barge canal) into lock 12 at Whitehall. Regardless of the name, which suggests pushing the boats, tugs would push or pull the groups of canal boats. On the lakes and rivers, however, the boats were almost universally towed.

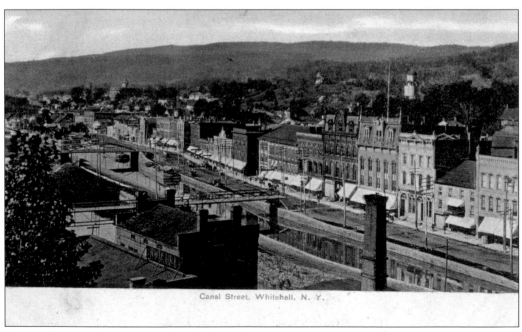

Canal Street, Whitehall, N. Y.

Pictured is Canal Street at Whitehall on the Champlain Canal, which was representative of many of the canal towns. The fronts of the buildings are a mix of many styles of architecture and, like today, were designed to attract patrons.

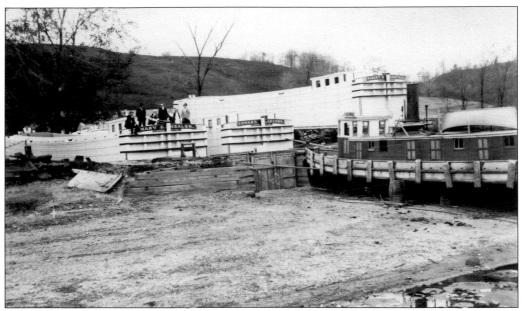

The boats *Mary E. Nealer, Edward Archer,* and *Robert B. Eightman* sit in dry dock waiting for their maiden launch into the canal system. The bright paint and lack of obvious damage, as compared to the steamboat on the right of the picture, mark them as new boats.

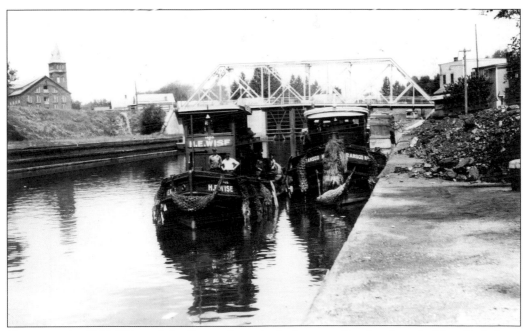

Two tugs, the *H.E. Wise* and the *Ransco,* have docked near a pile of coal on the New York State Barge Canal. The coal was the primary fuel source early in the history of the barge canal.

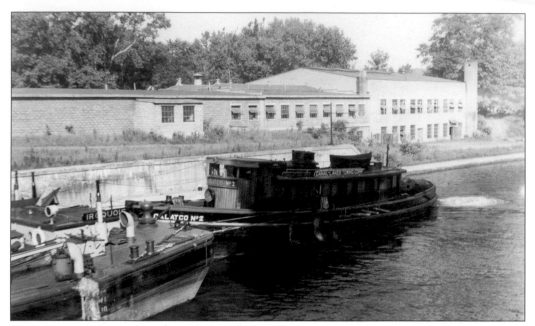

Here the tug *Calatco* of the Canal Lakes Towing Corporation pushes a group of canal boats.

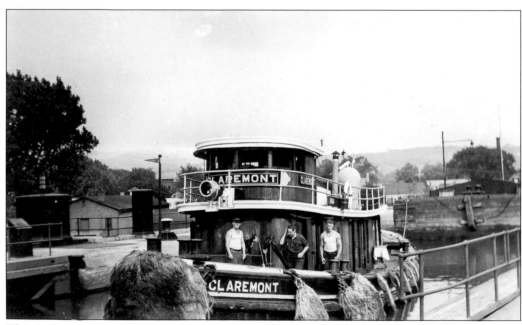

This is the tug *Claremont*, complete with hemp bumpers, a tired crew, and, behind the man furthest forward, a small dog acting as mascot.

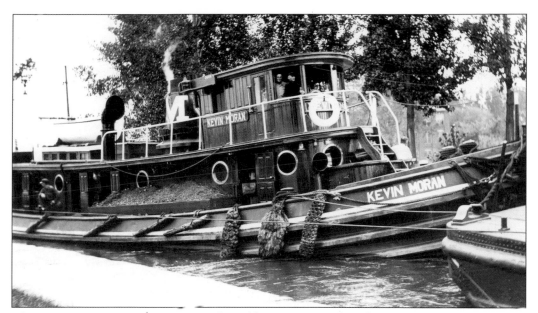

The tug *Kevin Moran* pushes a group of canal boats on an unidentified section of the barge canal. The coal for the boat's furnace is stored in a bin visible below just behind the pilot house.

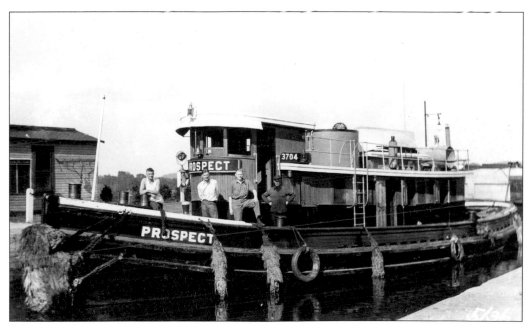

The crew of the tug *Prospect* pauses for a photograph in May 1936.

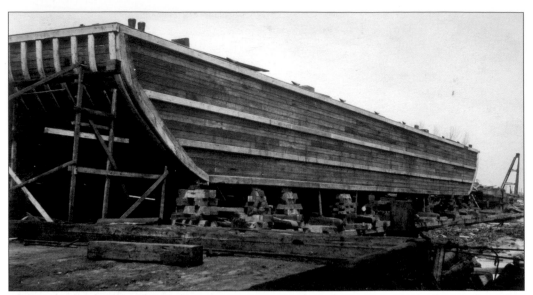

The construction of a canal boat was a basic business. The idea was to build the boat to fit within the locks and to hold as much cargo as possible. The boats were not built for beauty but were rough hewn and assembled as quickly as possible.

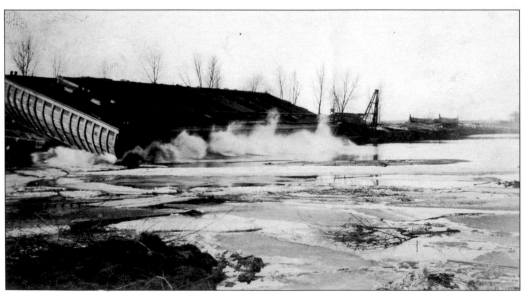

To launch the boats, support timbers were broken, and the boats literally slid sideways into the water.

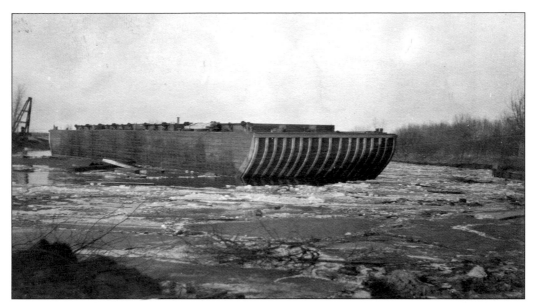

Once in the water, the interior portions of the boats were finished, and then the boats were quickly put into use. This boat was built at either the beginning or end of the canal season, given all the ice that surrounded the boat.

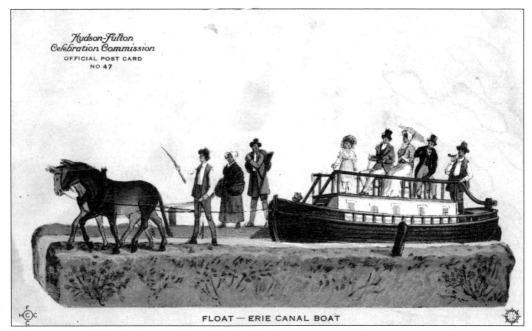

Hudson-Fulton Celebration Commission
OFFICIAL POST CARD
NO 47

FLOAT — ERIE CANAL BOAT

In September 1909, the State of New York held a dual celebration that was a statewide gala event. The event was designed to recognize the 300th anniversary of Henry Hudson being the first European to learn of the existence of the Hudson River and the 100th anniversary of Robert Fulton's first successful test of a steam engine that was conducted on the Hudson.

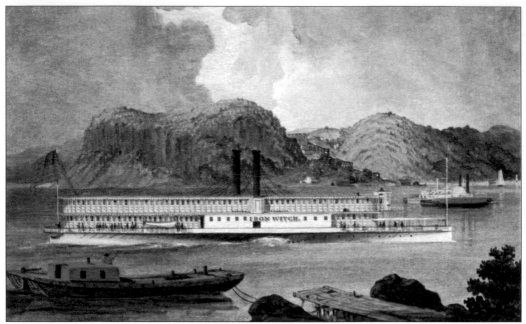

Robert Fulton's steam engine (1807) was quickly perfected, the result being massive steam-powered vessels that plied the waters of the Hudson River and the Great Lakes. This postcard is of the steamer *Iron Witch* and was painted by J. V. Cornell around 1846. The original painting is held within the collection of the New-York Historical Society.

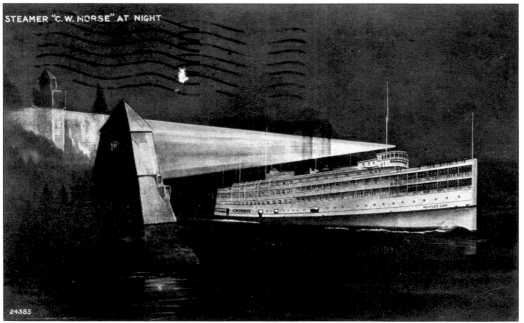

The steam-powered paddle wheeler *C. W. Morse* was built in 1903 in Wilmington, Delaware, and was intended to be a commercial passenger steamer on the Hudson River. It was commissioned in December 1917 by the U.S. Navy as a receiving ship and contributed to the broader World War I effort. At the conclusion of the war, the ship was returned to civilian operations. (Courtesy of the Naval Historical Center, Washington, D.C.)

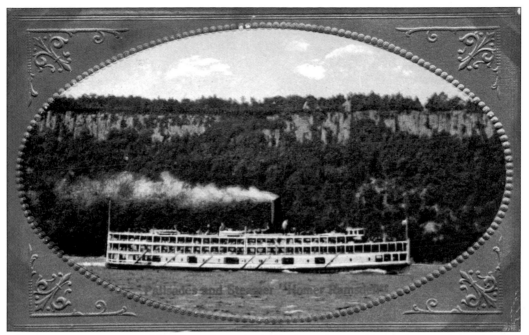

The steamer *Homer Ramsdell* moves along the Palisades. This card has a faux guilt border that has nothing to do with the historical interpretation of the image; rather, it is a wonderful tool for adding a bit of elegance to the otherwise ordinary postcard.

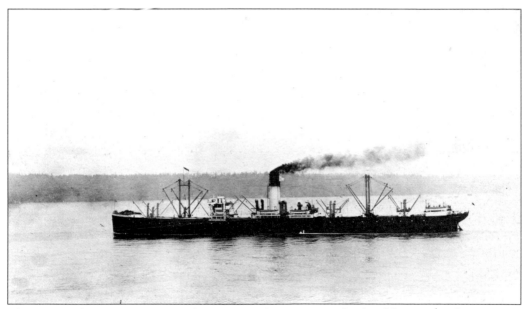

This image of an oceangoing vessel epitomizes the economy of scale of the capacity for shipping. The Clinton's Ditch boats from the 1820s to the 1840s carried about 30 tons. The canal was enlarged between 1835 and 1862 to allow boats a maximum capacity of 260 tons. The New York State Barge Canal was designed to allow 2,000 tons of cargo. The ship in this image can carry many times the capacity of the barge canal.

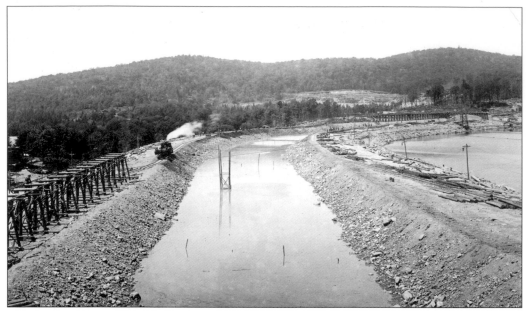

This image was likely taken somewhere in the Mohawk Valley and is part of the barge canal construction. The steam-powered rail car and the crewmen swarming both embankments beyond the car help to illustrate the massive undertaking in creating such a large canal system throughout the state. This image was taken by the New York Department of State Engineer and Surveyor.

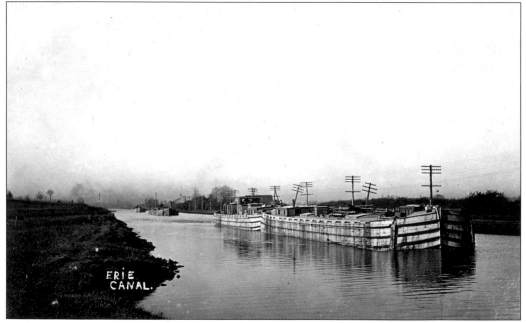

Here a former towpath era boat has been converted to a tug boat and is pushing a second converted towpath era boat on the completed Barge Canal. The state set as one of its priorities the ability of boat owners from the towpath era canal to transition their boats to the new system. The boat being pushed by the converted tug is called a consort barge. It was redesigned to be moved by tug through the new system.

BIBLIOGRAPHY

Bensel, J. A. *Annual Report of the State Engineer and Surveyor of the State of New York.* Vol. I. Albany, NY: J. B. Lyon Company, 1914.

Bond, Edward A. *Report of the State Engineer and Surveyor of the State of New York.* Albany, NY: James B. Lyon, 1901.

McFee, Michele A. *A Long Haul: The Story of the New York State Barge Canal.* Fleischmanns, New York: Purple Mountain Press, 1998.

Severance, Frank H. *Canal Enlargement in New York State and Related Papers.* Vol. 13. Buffalo Historical Society Publications. Buffalo, NY: Union and Times Press, 1909.

Shaw, Ronald E. *Erie Water West: A History of the Erie Canal, 1792–1854.* Lexington, KY: University Press of Kentucky, 1990.

Skene, Frederick. *Barge Canal Bulletin.* No. 1. Albany, NY: Department of the State Engineer and Surveyor of the State of New York, February 1908.

Smith, Ray B. *History of the State of New York, Political and Governmental, National Party Histories.* Syracuse, NY: Syracuse University Press, 1922.

Sullivan, Dr. James. *History of New York State: 1523–1927.* Vol. 1. New York: Lewis Historical Publishing Company, 1927.

Way, Peter. *Common Labor: Workers and the Digging of North American Canals 1780–1860.* Baltimore: Johns Hopkins University Press, 1997.

Whitford, Noble. *The History of the Barge Canal of New York State.* Albany, NY: J. B. Lyon Company, 1921.

Williams, Frank M. *Annual Report of the State Engineer and Surveyor of the State of New York.* Vol. I. Albany, NY: J. B. Lyon Company, 1918.

———. *Annual Report of the State Engineer and Surveyor of the State of New York.* Vol. 2, Albany, NY: J. B. Lyon Company, 1918.

Wotherspoon, William W. *Report of the Superintendent of Public Works on Canals.* Albany, NY: J. B. Lyon Company, 1919.

www.arcadiapublishing.com

Discover books about the town where you grew up, the cities where your friends and families live, the town where your parents met, or even that retirement spot you've been dreaming about. Our Web site provides history lovers with exclusive deals, advanced notification about new titles, e-mail alerts of author events, and much more.

MADE IN THE USA

Arcadia Publishing, the leading local history publisher in the United States, is committed to making history accessible and meaningful through publishing books that celebrate and preserve the heritage of America's people and places. Consistent with our mission to preserve history on a local level, this book was printed in South Carolina on American-made paper and manufactured entirely in the United States.

Find Your Place in History.

and handwriting skills because the students see the teacher writing their ideas and words. Children need to "read" songs, stories, and verses from charts and class books that they have seen their teacher write in the classroom.

The next step in developing handwriting skills requires students to practice writing the letter they are learning. After they have finished writing the letter three times, the teacher asks them to compare their letters to the model and draw a circle around their best letter. At this time, the teacher should help any children who are experiencing difficulty. These youngsters may need to trace models or have the teacher guide their hand to help them develop a better image of the letter.

The children who have formed the letter acceptably should write words that contain that letter. This will give them additional practice, so they will not forget the letter formation. Some teachers combine handwriting and phonics instruction so children can list words that include both a phoneme they are studying and a letter in the manuscript alphabet. Children should make books (Chapter Nine), greeting cards, pictures, charts, maps, letters, and signs. These activities create a functional context for handwriting skills, while making handwriting an integral part of the language arts program.

Reversals

Reversals occur frequently during the early stages of handwriting. Most reversals are the result of inexperience in reading and writing letters. Children are simply not aware of the details that distinguish one letter or one word from another. In most cases, reversals are *not* a symptom of learning problems. Youngsters who are inexperienced in dealing with print have not had a chance to orient themselves to letters and their placement in space. During their preschool years, they recognized a toy truck whether it was upside down, on its side or had a wheel broken off; but when looking at letters, a *b* becomes a *d* when it is turned around. In this situation, spatial orientation is significant. With experience, children learn to attend to the details in letters and words. Many reversals disappear during first grade, although some children continue reversing in second grade. Second-grade reversals should not cause alarm because most of them are insignificant and will gradually disappear as children acquire more experience with print.

Teachers can help prevent reversal problems. First, they should avoid mutually interfering discriminations which are letters and words that are very similar like *b* and *d*, or *saw* and *was* (Bryant, 1965). Students are more likely to confuse similar words and letters when they are introduced together; therefore, teachers must avoid introducing similar letters and words at the same time. Instead, introduce one of the easily confused letters like *b* and have students practice reading and writing the letter until they know it so well that they cannot forget it. This process may take several weeks. After students thoroughly know one of the letters or words that are easily confused, introduce the other and teach it to the same level understanding before presenting materials that contain both items at the same time.

Learning correct letter formation helps children avoid reversals. Correct letter formation is reinforced when students see teachers demonstrate the correct beginning point, the correct direction of motion, and correct sequence of multipart letters when they write on chalkboards and charts.

D'NEALIAN HANDWRITING

D'Nealian handwriting is a recent development in handwriting systems. The D'Nealian alphabet is shown in Figure 11.3. The lower-case letters in this system are similar to cursive lower case, so that when students make a transition from manuscript to cursive they can merely join the letters to-

See for yourself how easy it is!

Experience how easy it is to write D'Nealian manuscript letters. Using a felt-tip pen or grease pencil, trace the D'Nealian alphabet on the acetate overlay. Arrows and stroke numbers offer guidance in direction and sequence.

Where's the transition?

With D'Nealian manuscript, there's hardly *any* transition. That's the feature that is making this handwriting method the favorite of teachers from coast to coast. All you do is add a few simple joining strokes (shown in red) and—presto—you're writing in D'Nealian cursive!

Figure 11.3 D'Nealian handwriting system.